Simply Paint
FLOWERS

Dedication

For Arthur and Andrew.

Acknowledgements

There are several people I need to thank for their contributions to *Simply Paint Flowers*.

Firstly, thank you to everyone at Search Press, in particular Carrie Baker and Katie French, for their support in creating this book.

A big thank you to my Dad, my Mum, my sister Charlie, and the rest of my incredible family, for their endless kindness and belief in me.

To my dearest friends Alice McCaffrey, Anna Peynado, Francene Turner and Molly Yi: thank you for giving me the confidence to start painting again.

To my wonderful partner Andrew: thank you for your encouragement and support at every stage of the process. Quite simply, I couldn't have done it without you.

And to my son Arthur, thank you for being my inspiration; everything I create is for you.

First published in 2023

Search Press Limited
Wellwood, North Farm Road,
Tunbridge Wells, Kent TN2 3DR

Text copyright © Rebecca MacCarrick 2023

Photographs by Mark Davison at Search Press Studios

Photography and design copyright © Search Press Ltd. 2023

ISBN: 978-1-80092-039-2
ebook ISBN: 978-1-80093-032-2

The Publishers and authors can accept no responsibility for any consequences arising from the information, advice or instructions given in this publication.

Suppliers
If you have difficulty in obtaining any of the materials and equipment mentioned in this book, then please visit the Search Press website for details of suppliers: www.searchpress.com

To see more of the author's work, visit:
www.bybeckyamelia.co.uk
Instagram: @beckyamelia_art

BECKY AMELIA

Simply Paint
FLOWERS

25 inspiring designs in easy steps

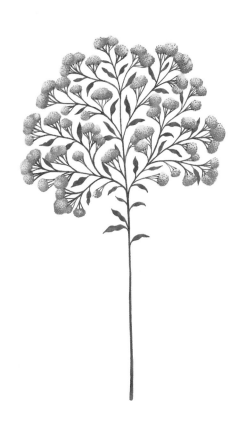

SEARCH PRESS

Cont

Introduction 6
Materials 8
Basic techniques and tips 12

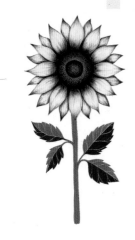 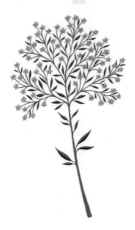 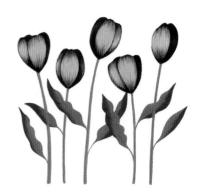

ents

Introduction

Flowers are an endless source of inspiration. Throughout history and to this day, they are one of the most popular subjects for illustration and design. Flowers are incredibly varied in colour, shape, size and structure, so there are infinite variations of painting florals. Many of the flowers I paint are based on real flowers; the rest are a product of my own imagination. There are many excellent books on creating scientifically accurate botanical illustration, but what I want to focus on here is the enjoyment of the painting process itself.

Painting does not have to be daunting; you don't have to spend years studying classical painting techniques, and you don't have to invest in expensive tools or equipment. I didn't study art after secondary school, and I only started painting again, as a hobby, relatively recently. Creativity, a bit of guidance, and a few basic products are all you need to get started.

In this book, we are going to create 25 beautiful floral paintings, which I have broken down into simple, easy-to-follow steps. I will not assume any prior knowledge or experience of painting. Above all, I want you to love the process of painting these flowers and creating something beautiful.

Each project will start with a simple pencil sketch – it might be the whole layout of the painting, or it might just be the placement of the stems. I will also show you the colour swatches you'll need – you may need to mix some of these, so you can use them as a reference to mix up all the colours before you start painting. We'll then work through around eight to ten simple steps to create a gorgeous finished painting.

Although these projects are designed with a certain outcome in mind, please don't feel like you have to follow my illustrations to the letter. You can't mix the exact shade of blue I've used? That's okay! Your leaves have gone in a different direction to mine? Absolutely fine! Flowers in nature are not perfect and uniform, so please don't feel like your paintings need to be.

I hope that once you've worked through some of these projects, you'll have the confidence to experiment with your own arrangements and floral illustrations. Throughout the book, you'll find some little suggestions on how you could develop your own ideas based on these projects, to create something truly original.

Oscar Wilde once wrote: 'A flower blossoms for its own joy.' I try to have a similar outlook: I paint flowers for my own joy, and I hope you are inspired to do the same.

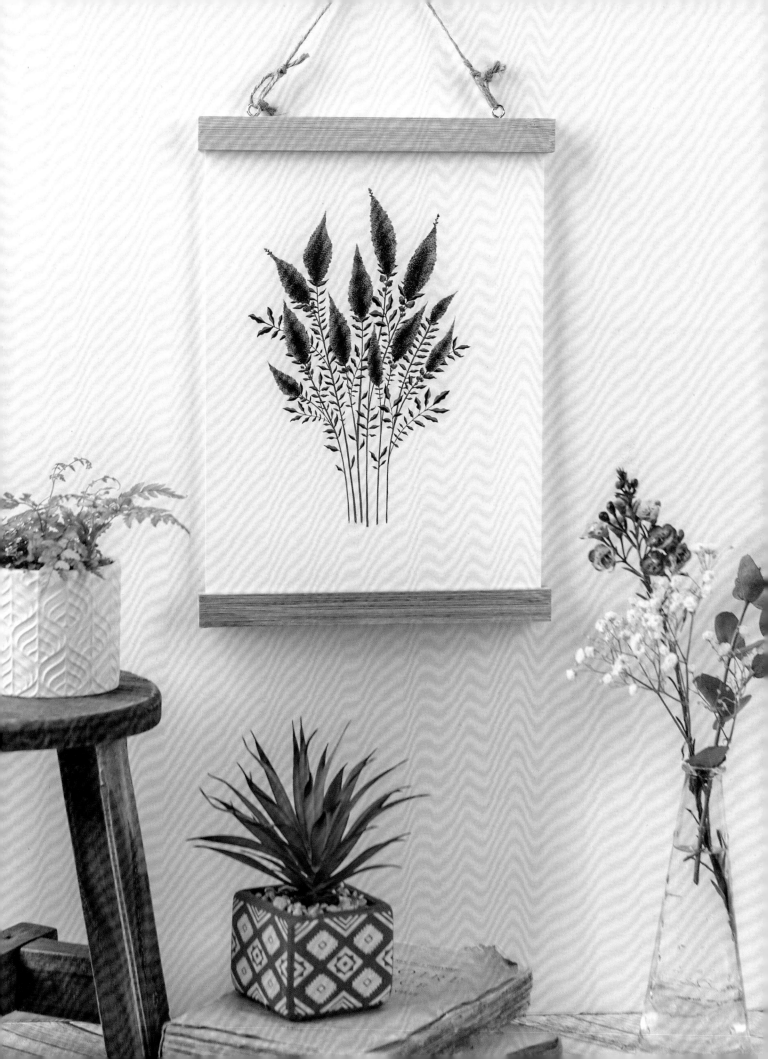

Materials

Let's have a look at your toolkit. If you've ever dabbled in painting before, you may already have some of these products lying around. But if not, you don't need to break the bank by buying top-quality paint or the finest brushes. Almost all the products I use regularly are inexpensive and readily availble from high-street stores or easily found online. Below is what I recommend.

PAINT

Here's where we can be a little bit flexible. First, let's talk about the two types of paint I use:

GOUACHE

Gouache is my favourite type of paint, and in my opinion easier to use than watercolours. Gouache paints act similarly to watercolours, but they tend to be opaque, and you can paint light colours on top of dark colours.

WATERCOLOUR

People are quite often daunted by watercolour paints, which I can completely understand – though you will find that I use them in a much simpler way than traditional watercolour artists. These paints lend themselves very well to blending colours, and you can get some lovely effects, but they are limited in that you can't add a light colour on top of a dark colour, and they are often not opaque.

I use Kuretake Gansai Tambi watercolour pans (which are highly pigmented), and I have just a few tubes of Winsor & Newton Designers Gouache (white, yellow, pink and green). I use a mixture of both.

If you have a watercolour set lying around, I'd recommend buying just one tube of white gouache. You can often mix a standard coloured watercolour with a bit of white gouache and voilà – you have something like a coloured gouache! If you are starting from scratch, I would start with a beginner's set of gouache tubes for the projects in this book, making sure you have a nice range of colours. Most sets will include these as standard, but I would recommend having white, black, yellow, red, blue, brown, purple and at least one shade of green (for botanical painting, it's quite nice to have a couple of different greens but this is not necessary – you can always mix different greens anyway).

Whatever set you get, I'd recommend taking a little bit of time to swatch the colours on a spare sheet of paper. This is because the colours often look very different on paper than they do in the pans/tubes. If you're feeling adventurous, you could also experiment with mixing some of the colours and swatching those too. Keep your swatch sheet, and label it – it might be helpful for you to refer to later.

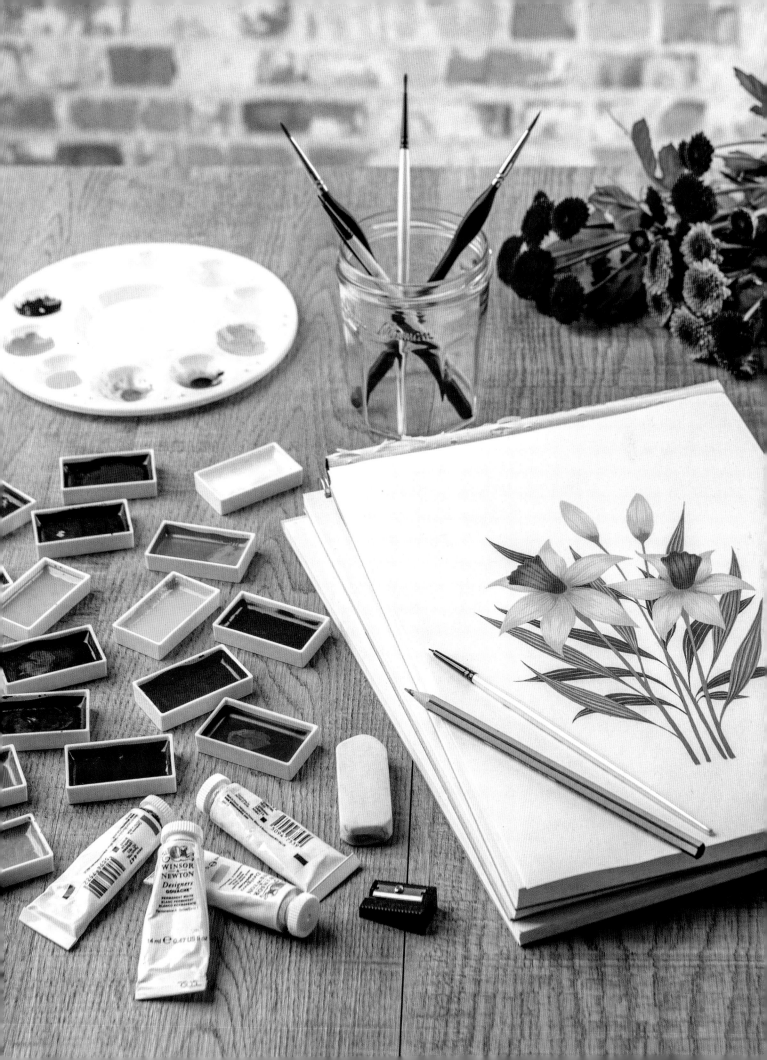

PAPER

You'll need some watercolour paper. I use Daler-Rowney Aquafine 300gsm (140lb) Smooth Watercolour paper, which is fantastic quality and value for money. The techniques I use don't generally get the page too wet, which means you don't need a more heavy-duty paper than this. Some people prefer a textured paper, but I personally find smooth paper easier to paint on. All the paintings in this book were painted on A4 (210 x 297mm/8¼ x 11¾in) paper, which is my preferred size.

A PENCIL, SHARPENER AND ERASER

You'll see throughout this book that I begin with a pencil sketch before laying down any paint. I like to use a hard pencil (labelled with 2H or 4H), as they're usually a bit lighter in colour, but a standard HB is perfectly fine. Along with this, you'll need a nice white eraser (I've used Staedtler since I was at school!) to correct any mistakes, and a pencil sharpener to keep your pencil lines nice and fine. Please note that the sketches in the book are not drawn at actual size, but instead are there to give you an idea of the shape to sketch. Your paintings could be any size you wish.

PALETTE

A simple plastic paint palette is perfect. They are inexpensive and can be easily found at most stationery stores. You could also use an old saucer or porcelain tile, but it's quite handy to have a palette with separate mixing pans.

BRUSHES

I use synthetic (nylon) brushes of the smallest sizes I can find – my most-used brush sizes are 0, 00 and 000. I'm not loyal to any particular brand, so whatever you can get your hands on is fine. You can find these in any art and craft shop. I like to use a separate, slightly larger brush to mix colours, and then keep my small brushes just for painting. I have used and enjoyed Daler-Rowney, Royal & Langnickel, Winsor & Newton, Cass Art and many other brands. Whichever brushes you get, make sure you look after them – don't leave them standing in the pot of water; wash them out, squeeze out excess moisture and lie them on a piece of kitchen paper when you're not using them. This will help preserve the bristles and prevent bending and shedding.

A CUP OF WATER

Any cup will do: an empty jam jar, a plastic tub, an old mug. A word of caution – if you like to enjoy a cup of tea or coffee while you're painting, make sure you're paying attention and don't confuse this with your paint water pot. I speak from experience here – paint water does *not* taste nice!

Basic techniques and tips

COLOUR MIXING AND SWATCHES

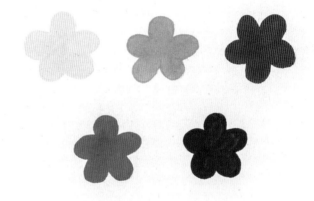

Before I start painting, I usually mix up the colours I'm planning to use. You'll see that a lot of my paintings use several shades of the same colour, which I create by mixing varying quantities of white with that colour. For example, the petal above is painted using three shades of pink. To create these, I mixed white with magenta, adding a little bit more white each time I wanted to make the shade lighter. This isn't an exact science, and will depend on the particular paints you are using, so I encourage you to experiment here.

I always paint a swatch of the colours I'm going to use on a spare piece of paper. This is just to make sure they are mixed how I want them, and that they look good together. Gouache in particular often gets a bit darker when it dries, so make sure you allow your swatches to dry to get a true representation of the colours. Your swatches don't need to be flower shapes like mine, but you'll see that I've included those with each project.

LINES IN NATURE

Straight lines are very rare in flowers. Petals, leaves and stems are almost always curved in soft lines. This is an important factor in making your flowers look natural and realistic. I do, however, use a template for drawing a perfect circle for some of the initial pencil sketches. Draw around a circular object, like a small bowl, or use a compass.

ALLOW YOUR PAINT TO DRY

My number one tip when people ask me about painting is this: have patience and let your painting dry. Unless you are using a wet-on-wet technique (which I very rarely do, and won't be covering in this book), it is crucial to let one layer dry before you add another. Similarly, if you are painting two adjacent sections (for example, the stem and the petals of a flower), let the first one dry before you move on to the second. If you don't, the paints will bleed into each other, and it will end up looking like the painting below left, when you want it to look like the one below right.

LAYERING FOR SHADING

Layering is my preferred technique for adding shading and depth to a painting.
I'm going to show you how I would paint a single petal using this technique, which
you will see repeated throughout this book. Don't worry – it's really simple!

1 Starting with the lightest pink, paint a block all over the petal, then let it dry.

2 Using the medium pink, add curved lines going from the inner and outer edge of the petal, in the direction the petal grows. These darker lines are shadows on the petal. They do not have to be regular – some will be longer, some shorter – but try to ensure they are all going in the same direction and following the same curve. Then let it dry (I'll stop going on about this now, but I can't stress enough how important it is for this technique!).

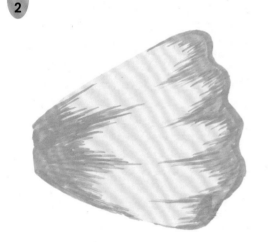

3 Using the darkest pink, add smaller lines where you want the deepest shadows to be, on top of the first layer of shadows. Again, these can be irregular, but there should be fewer of them than in the previous step.

4 You can now see that using those three layers, we have created the effect of a three-dimensional petal. A few more petals, following the same technique, gives you the full effect.

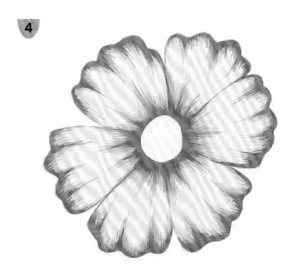

STIPPLING

Another technique I use a lot is dot work, or stippling. This involves lots of little dots, to create the illusion of three-dimensionality and depth. Let's look at creating the centre of the flower, continuing the previous example.

1 Paint a simple light brown circle as a base.

2 Paint dots all over the circle, painting them closer together around the outside and further apart in the centre.

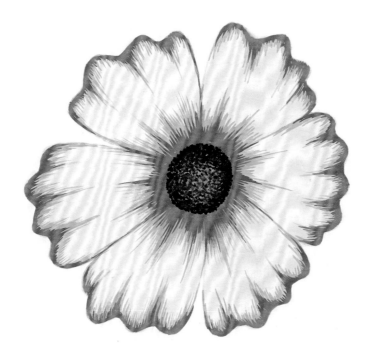

3 As you can see, the stippling has given texture as well as depth to the finished flower.

The
Projects

SUNFLOWER

One of the most recognizable flowers, the sunflower is a symbol of positivity and lasting happiness. This is a good project to start with as it incorporates my two most-used shading techniques: stippling for the centre of the flower, and layering for the petals (see pages 14–15).

COLOURS

Light yellow, medium yellow, orange, orangey-brown, white, light brown, medium brown, dark brown, medium green, dark green.

Sketch

Draw a circle for the centre of the flower (you can use a compass, or draw around a small circular object). Then draw simple petal shapes extending from it on all sides, evenly spaced – this is the front layer of petals. Then draw a second layer of the same type of petals behind the front layer. Finally, draw a straight stem with several notched leaves growing off it.

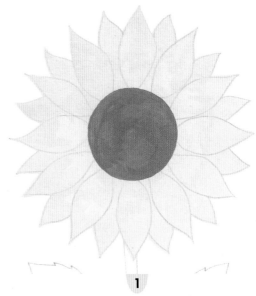

1

Starting with the lightest yellow and the lightest brown, block in the colours of the petals and the centre of the flower.

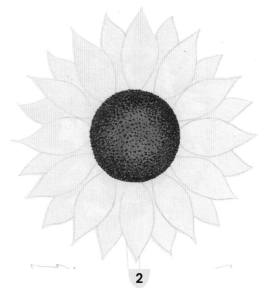

2

First we're going to work on the centre of the flower. Using the medium brown and a small brush, paint dots all over the centre of the flower. Make the dots closer together around the outside of the circle, and more spaced out in the centre.

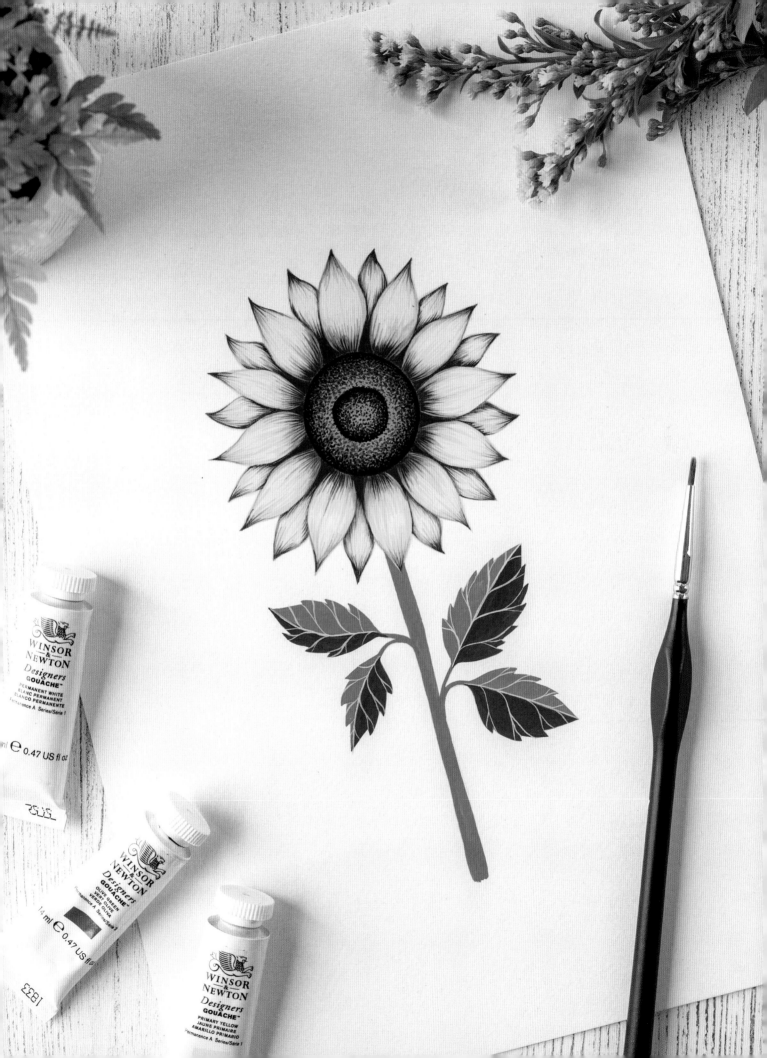

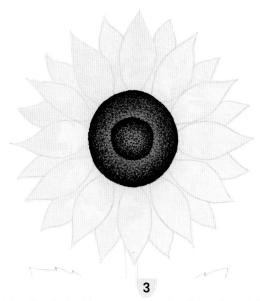

3

Using the darkest brown, repeat step 2, again painting the dots more densely around the very outside of the circle. Repeat this process on a smaller circle inside the first circle.

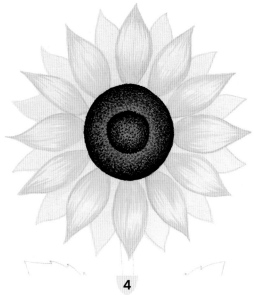

4

Let's move on to the petals, first focusing on the front layer. With the medium yellow, paint fine lines extending from both the inner and outer edge of each petal, following the natural curved outlines of the petals.

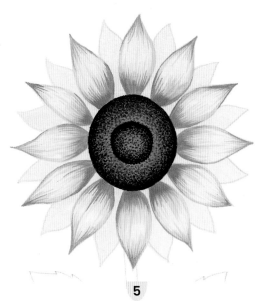

5

Follow the same technique as in step 4, this time using the orange and not extending the lines quite so far along the petal.

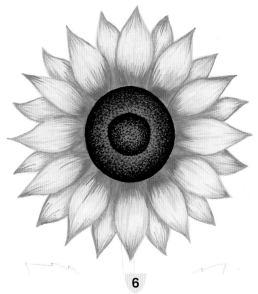

6

Repeat steps 4-5 on the back layer of petals.

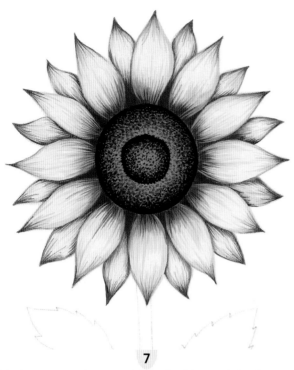

7

With the orangey-brown, add the final layer of shading to all the petals by painting a few short lines at the inner and outer corners of the petals. Add more shading to the back layer of petals here, particularly at the centre of the flower, as they are in the shadow of the front petals.

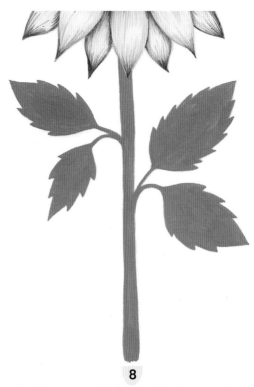

8

Paint the stem and a few notched leaves with the medium green.

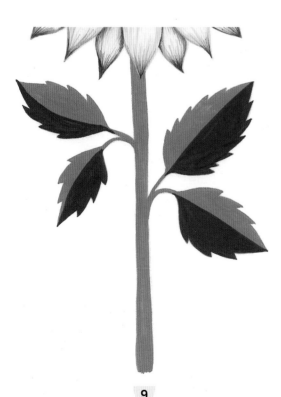

9

Paint half of each leaf with a darker green to add three-dimensionality.

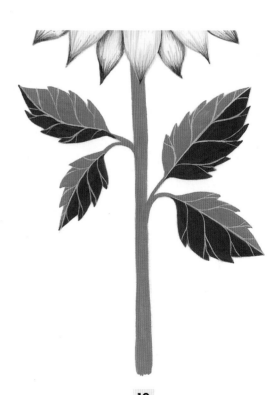

10

Add final details to the leaves by painting in the veins using white.

FORGET-ME-NOTS

These pretty little blue flowers are one of my favourites to paint – you can make a stem of forget-me-nots as simple or as complicated as you like by adding more flowers branching off the main stem. The technique remains the same no matter how many flowers you include, so feel free to experiment!

COLOURS

Light blue, medium blue, cream, medium green, dark green.

Sketch

Draw a single stem, which branches off into three smaller stems. Each of these branches will then split into three again, and then each of those branches will split into several smaller branches, and so on (this is where you can make the sketch more complex if you want to, by continuing to branch the stem). You don't need to be too precise here, or sketch the placement of the flowers – it's just helpful to have a general idea of where the stems will be.

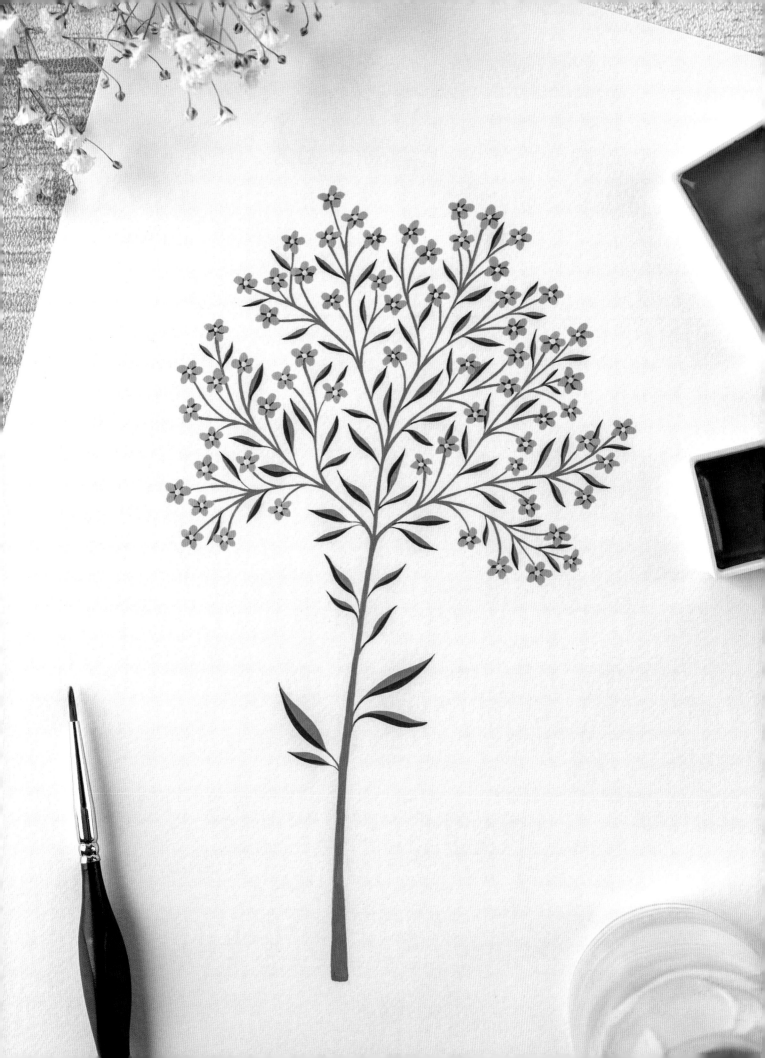

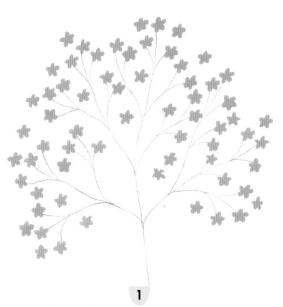

1

Around the end of each branch, paint several simple five-petalled flower shapes using the light blue.

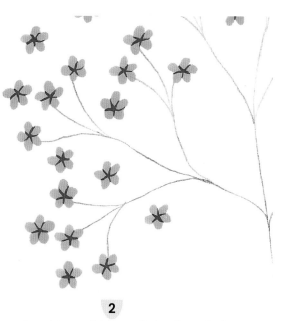

2

Using the medium blue, paint a small star shape in the centre of each flower, with each line of the star extending outwards to separate the petals.

3

Paint a cream dot at the centre of each flower.

4

Start joining up the flowers to the branching stems using the medium green paint. I find it helpful to start painting from the flowers and join each smaller stem to the main stem (rather than starting with the main stem and painting outwards towards the flowers).

5

Paint the main stem and, using the same green, paint a few small leaves – these can be growing from any point on the stem, but they will tend to be smaller the further up the stem they are. Notice that the biggest leaves are near the bottom of the stem, and that the stem itself is thicker at the bottom.

6

Paint half of each leaf with a darker green to add depth.

A ROW OF TULIPS

Whenever I am stuck for inspiration, I always come back to tulips – not only are they one of my favourite flowers, but they are also relatively simple to paint. Tulips come in such a wide variety of colours, so you can use the following technique with a different colour palette if you want to experiment!

COLOURS

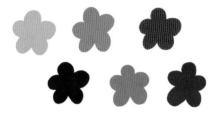

Light pink, medium pink, dark pink, red, medium green, darker green.

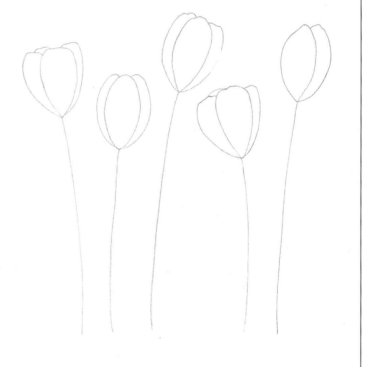

Sketch

Draw five stems, with the tops roughly evenly spaced apart. Sketch a tulip shape (with elongated oval-shaped petals, pinched in at the bottom) at the head of each stem. Some tulips are more opened up than others, so you can practise a few different angles of tulip here if you want to.

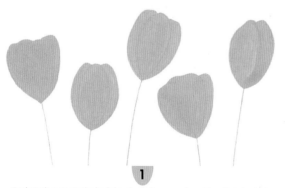

1

Paint the petals in block colour using the light pink.

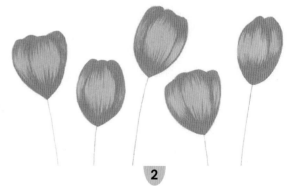

2

Using the medium pink, create some shading by painting lines that extend from the bottom of the petals upwards, and from the top of the petals downwards. At the outer edges of each petal, extend these lines all the way down to separate and define. Add more shading to any petals that are further back, as they would be in the shadow of the front petals.

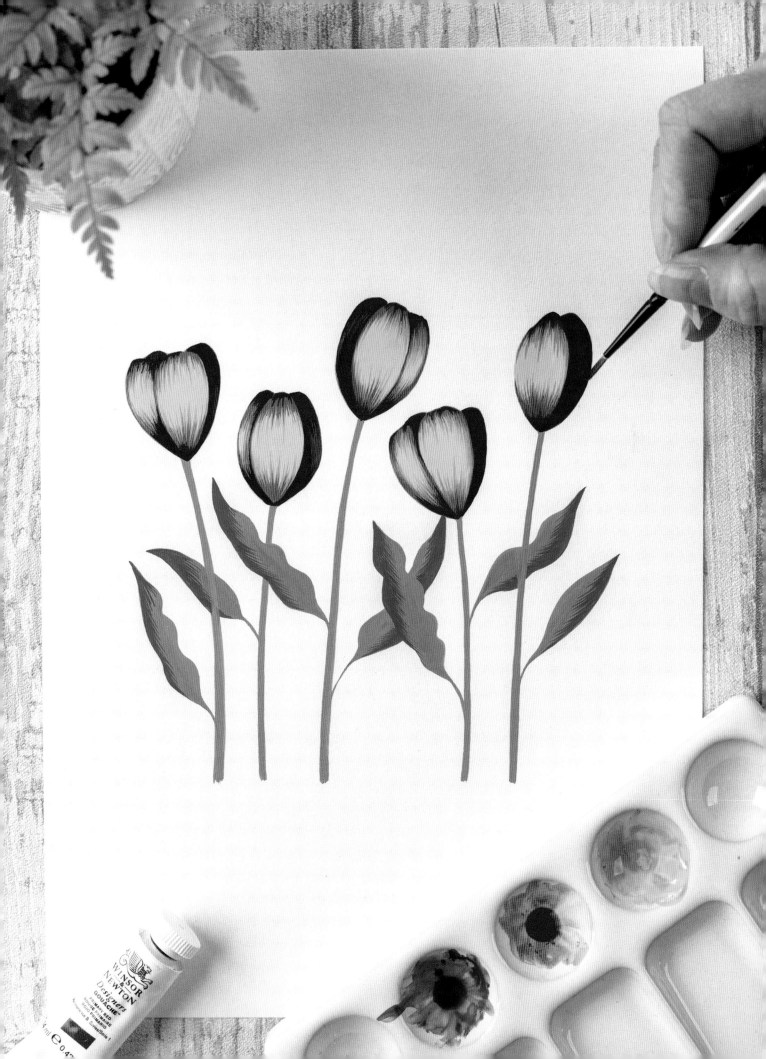

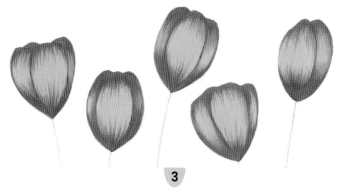

3

Repeat step 2 using the dark pink paint, not extending the lines quite so far this time.

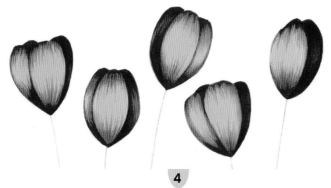

4

Add just a few lines of shading at the very top and bottom edges of the petals, using the red paint. Paint some of the back petals completely red, to give the impression that they are in shadow.

5

Using medium green, paint in the stems.

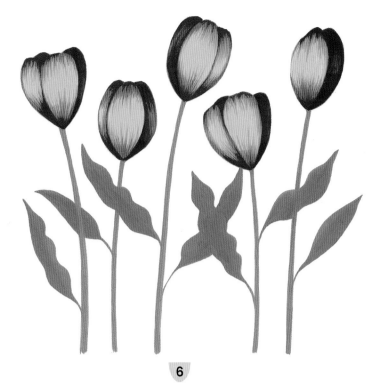

6

Again with medium green, paint in a few curved, wavy leaves. These can overlap with each other for a more natural composition.

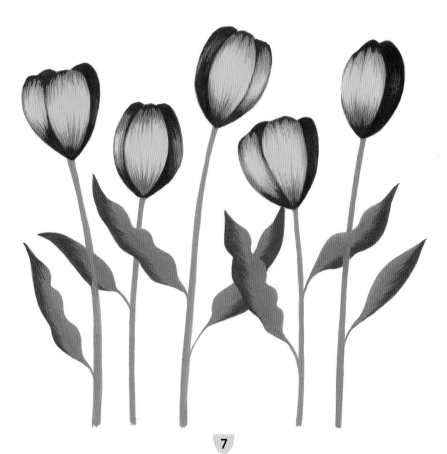

7

With the darker green, add a bit of line shading to each leaf: starting at the tip and continuing down one edge of the leaf, paint lines downwards towards the base of the leaf.

BABY'S BREATH

Baby's breath, or gypsophila, are beautiful little filler flowers – you'll often find them in bouquets with roses, peonies and other larger, more ostentatious flowers. It's a useful flower to learn to paint, as you can easily incorporate them into wreaths or bouquets later. They come in many different colours, but we're going to paint a classic white one here.

COLOURS

Light green, medium green, dark green.

Sketch

Similarly to the stem we sketched for forget-me-nots (see page 22), draw a single stem that branches off into several smaller branches, each of which should then branch into further smaller branches. Again, you can experiment here – overlap some of the branches if you want, make them as simple or as complicated as you like.

1

Using the lightest green, paint little puffy cloud shapes around the ends of each branched stem. Each of these shapes is going to be painted to give the illusion of many tiny flowers, so they don't have to be uniform at all - they can be a real mixture of small, large and overlapping shapes.

2

Now let's add some shadow. With the medium green and the smallest brush you have, paint little dots all over the lower half of each cloud shape, with the dots closer together towards the bottom of each shape. They should be so densely painted at the very bottom of each shape that the colour is almost solid.

3

Using the darkest green, paint tiny dots over the bottom half of each shape, again painting them closer together at the very bottom of the shape.

4

Now we'll start joining the flowers to the stems. Each puffy cloud shape should be joined to the main stem with several tiny branching stems – this is to give the impression that each shape is composed of many tiny flowers.

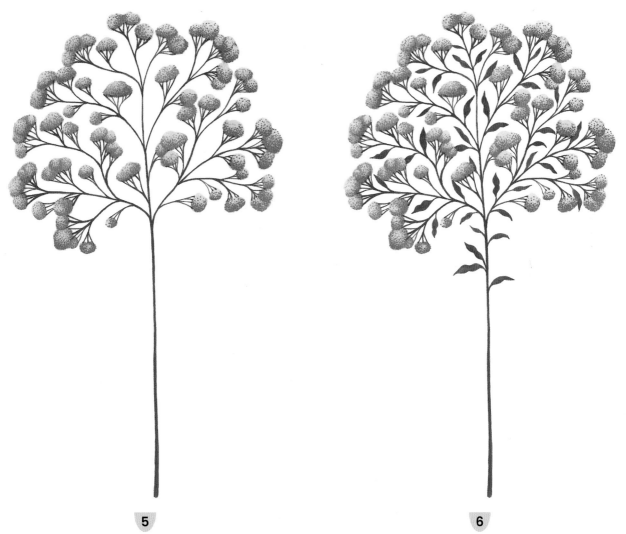

5

Continue painting each stem to join up with the main stem.

6

Add a few curved leaves anywhere along the stem with the dark green. The leaves should be smaller the closer they are to the flowers. You can add as many or as few as you like.

POPPIES

If you are a bit daunted by painting bunches or bouquets of flowers, don't be scared! They can be easily broken down into small, simple steps. This is a lovely one to start with – three bright red poppies will form the basis of our bunch of flowers, and then we'll add a few poppy buds and leaves to fill it out.

COLOURS

Bright red, burgundy, black, medium green, dark green, white.

Sketch

Draw three simple flower shapes, roughly in a triangle, each with four wavy-edged petals. Also sketch the stems, which should fan outwards from the bottom to the top (as they would in a bouquet of flowers).

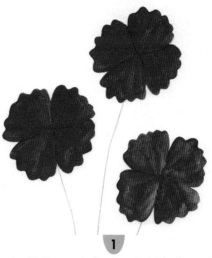

Let's start with the main flowers. Paint in the petals of the poppies using the bright red paint.

Using the burgundy paint, add some depth to the flowers by painting shading lines extending outwards from the centre of the flower. Paint the same shading lines from the outer edge as well, extending inwards. You can create the illusion of three-dimensional shadows along the wavy edge of the petal by painting the lines a bit longer where the petal curves inwards, and shorter where the petal curves outwards.

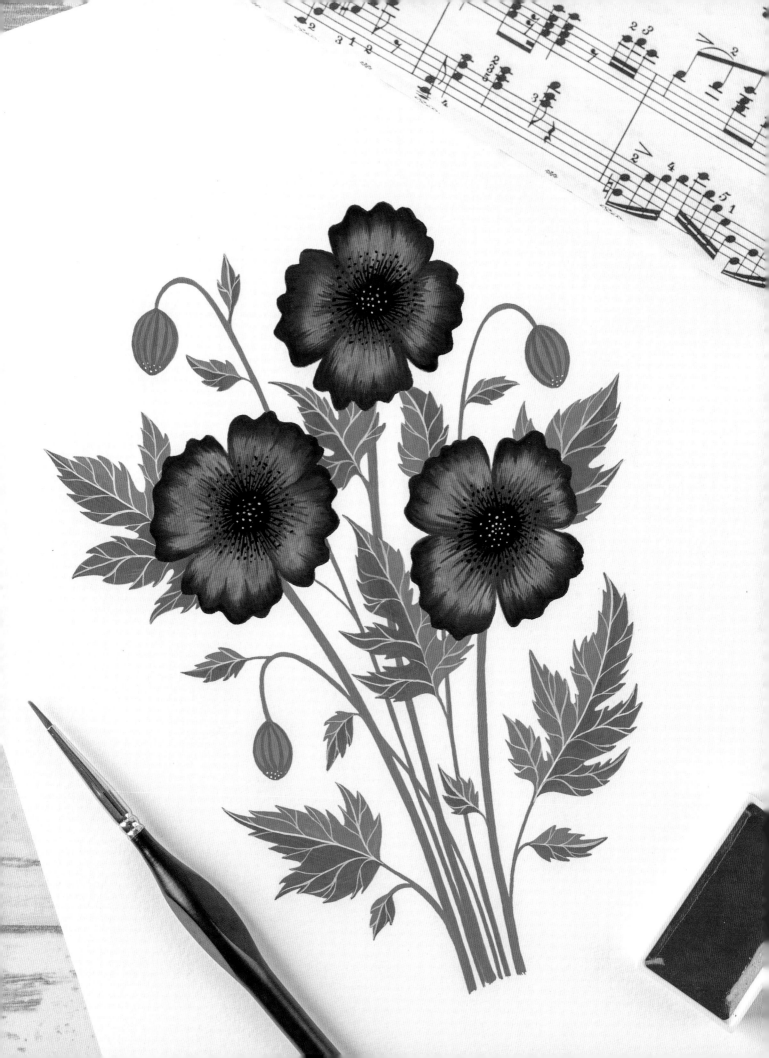

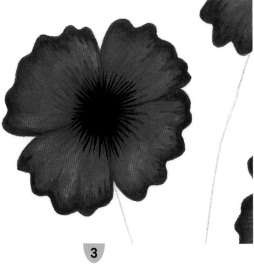
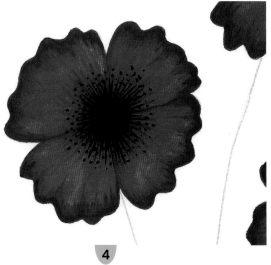

3

Paint a small black circle at the centre of each flower, and then paint thin black lines extending outwards all around the circle. These don't have to be perfectly uniform; some lines will naturally be longer than others.

4

Around the centre of the flower that you've just painted, paint a larger circle of small black dots.

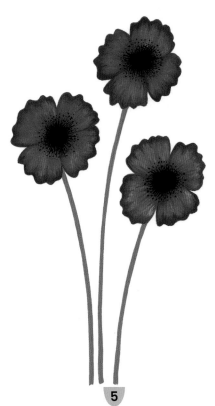

5

Using the medium green, paint the stems of the three poppies.

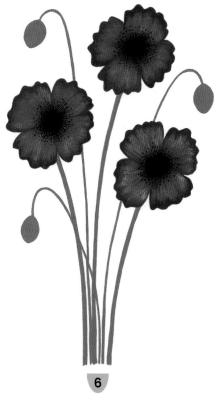

6

Still working with the medium green, paint three simple poppy buds – these will have slimmer stems than the actual flowers as they are not fully grown yet, and will end in a downturned bud shape. The stems can overlap and disappear behind the poppies in places – this will make your bouquet look more natural. If you are not confident painting these in freehand, pencil them in first!

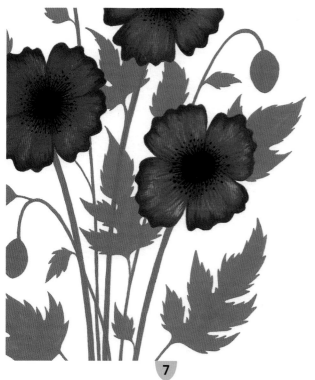

7

Now it's time to add some leaves – poppy leaves can have really interesting shapes, with spiky, notched edges. Paint in a mixture of small and large leaves, anywhere on the stems, with some of them hiding behind the poppies. Again, feel free to pencil these in first if that makes it easier.

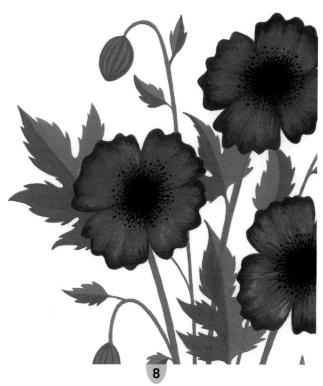

8

With the darker green, paint one half of each leaf to add some depth to the foliage, and add curved vertical stripes on the poppy buds.

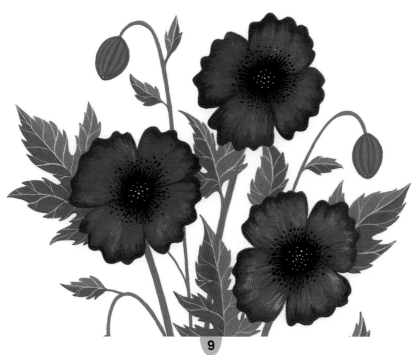

9

Add some final details with the white paint, including branching veins on the leaves and tiny white dots at the tip of each poppy bud and at the centre of each poppy flower.

CHERRY BLOSSOM

Cherry blossom is another one of my favourites – these beautiful and delicate pink flowers bloom in early spring and symbolize new beginnings. I love painting them – you can paint multiple branches for a more detailed painting, but I'm going to keep it simple here by showing you how to paint a single branch.

COLOURS

Light pink, medium pink, dark pink, dark brown.

Sketch

Draw a single curved line. This will be the overall shape of the branch, with many small flowers coming off it.

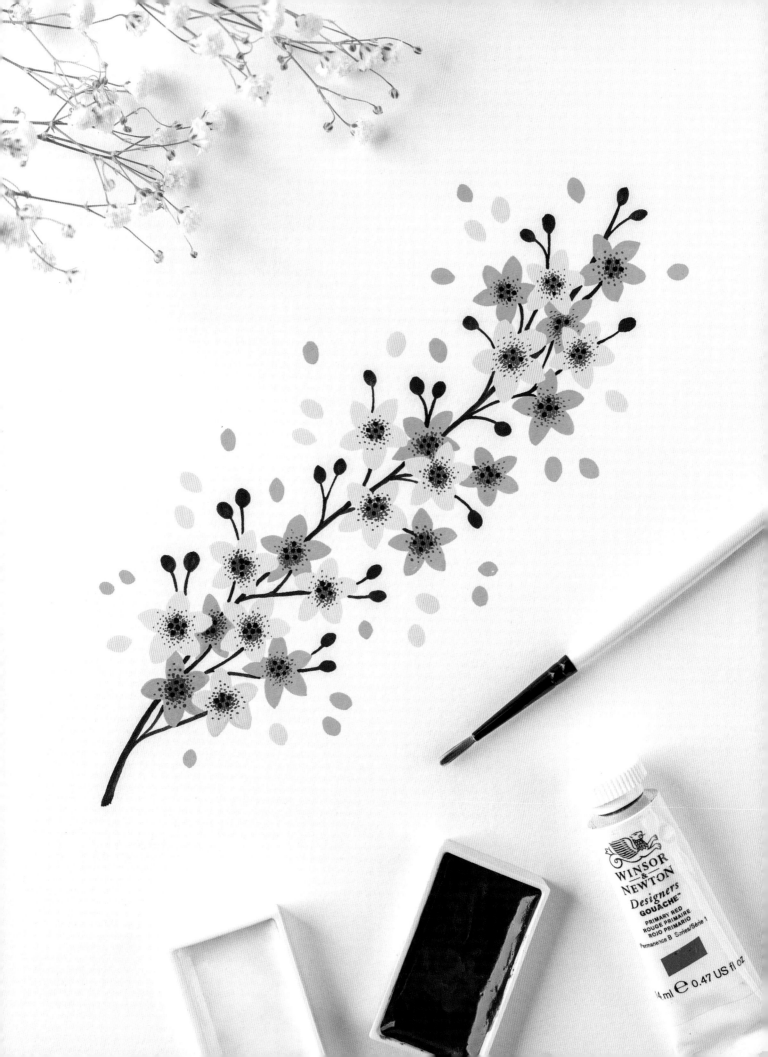

1

Start by painting small five-petalled flower shapes, in little groups along the sketched line, with the light pink paint.

2

Paint more of the same five-petalled flowers with the medium pink paint, again all along the branch, with some of them painted behind the light pink flowers from step 1.

3

Using the dark pink paint and the smallest paintbrush you have, paint tiny dots in the middle of each flower. At the very centre of the flowers, these dots should be painted so close together that the dark pink colour is solid, and they should be more spaced out as you move outwards from the centre.

4

On top of the dark pink dots, paint 5 or 6 slightly larger dots using the dark brown paint, right at the centre of each flower.

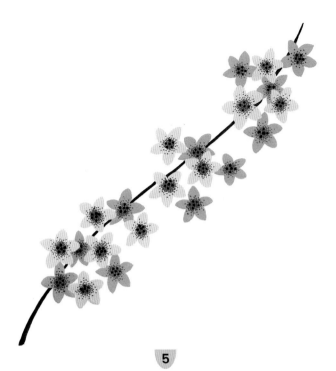

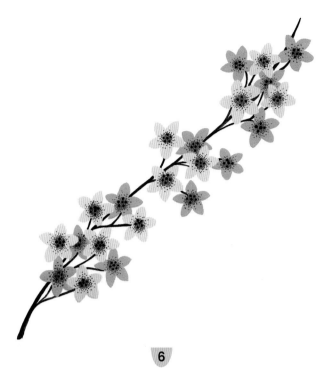

5

Using the dark brown, paint the branch where it can be seen between the flowers.

6

Still using the dark brown, join each flower to the main branch with a thinner stem. These thinner stems should be branching upwards and curving outwards from the main branch.

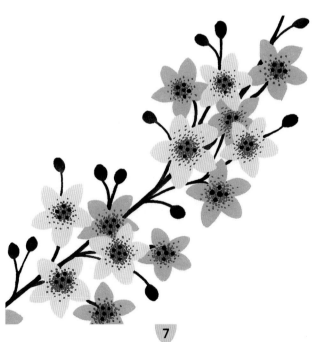

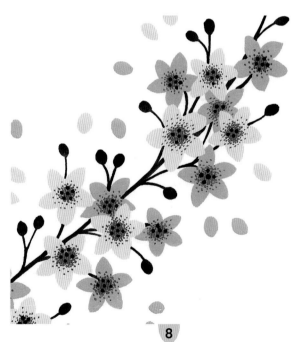

7

Add some small buds with the dark brown paint. Again, each one should branch outwards and upwards from the main branch, and end with a small oval shape – some should be single buds, while some should branch into two buds. These can be seen growing straight from the main branch, or peeking out from behind the flowers.

8

Using the light and medium pinks, add little petals all around the branch, as though a light breeze has just blown through and shaken the blossom petals loose from the tree!

A BUNCH OF DAFFODILS

Another springtime favourite: the daffodil. These sunny
yellow flowers are so bright and joyful, and I think they make
a lovely bouquet. Here, we're going to paint a dainty bunch
of daffodils, complete with leaves and flower buds.

COLOURS

Light creamy yellow, bright yellow, light orange,
deep orange, medium green, dark green, white.

Sketch

Draw two lines for the main stems, curving outwards from
each other. At the top of each line, draw a flower shape
with six pointed petals. Add a little curl to the tip of some of
the petals for a more realistic natural shape. Don't worry
about the centres of the flowers, as we will be painting
these in later.

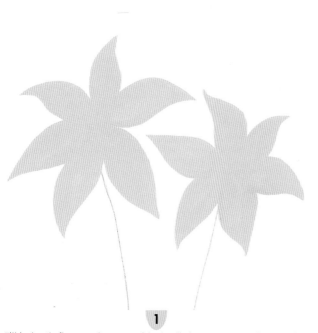

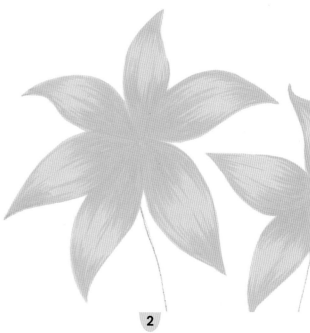

1

Fill in both flower shapes with the light creamy yellow paint.

2

Add some shading lines to the petals with the bright yellow paint, starting from the centre of the flower extending outwards, and the tips of the petals extending inwards, following the natural curve of the petals. These lines should vary in length, with a few of them going the entire length of the petals.

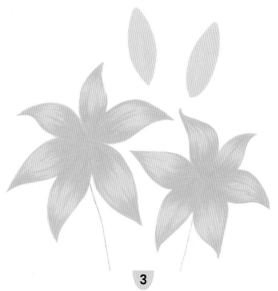

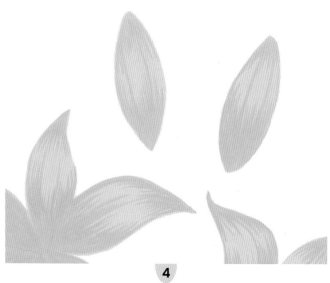

3

Paint two elongated oval-shaped buds, above the two main flowers, with the creamy yellow paint. You can draw these in pencil first if you like.

4

Using the bright yellow paint, add some shading lines to the buds, starting from the top and the bottom. Again, a couple of these lines should go along the entire length of the bud.

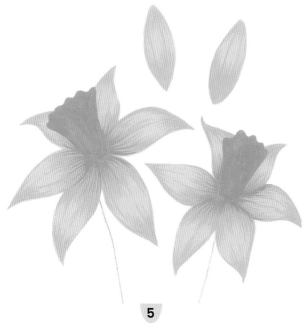

5

Now we're going to paint the centres of the flowers – again, you may find it easier to pencil these in first. Using the light orange, paint a trumpet shape coming from the centre of each flower, ending with a wavy edge. Using the same colour, paint just a few shading lines on the flower's petals, coming from the base of the trumpet shape and extending a little bit along each petal.

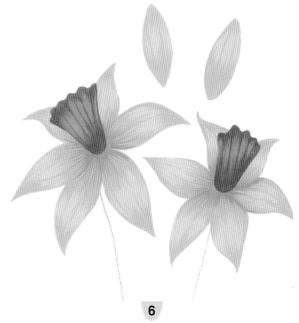

6

Add some shading lines to the daffodil centres using the deep orange paint. Start with five or six lines painted along the whole length of the trumpet, and then paint in some shorter shading lines from the top and the bottom of the trumpet.

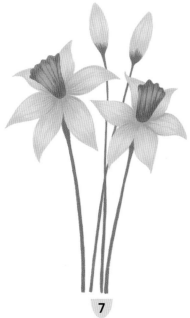

7

Paint over the initial sketch lines for the stems of the main flowers using the medium green paint. Then paint in the stems for the buds. I have painted the stems of my buds to be crossing over, for a more interesting composition. Where the stems meet the buds, add a few short green lines of varying lengths.

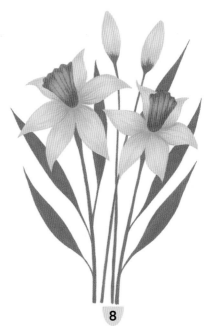

8

With the medium green, paint a few leaves coming off the stems. Daffodil leaves are long and slender, with pointed tips, almost like large blades of grass. Paint these leaves all growing upwards, with some of them disappearing behind the flowers.

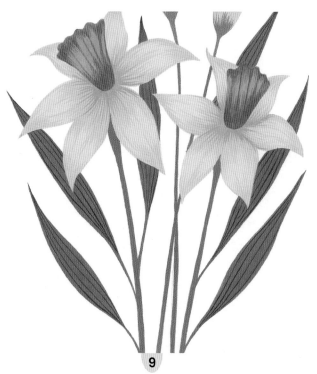

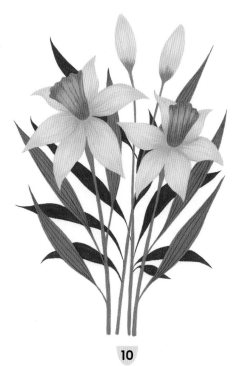

9

Using the dark green paint and the thinnest paintbrush you have, paint lines along the whole lengths of the leaves, following the curved shapes.

10

Add some more leaves using the dark green paint, behind the front layer of lighter leaves. I have painted these ones growing upwards again, but with some of them arching over so that their tips end facing downwards.

11

Add some very thin white lines along the length of all the leaves, again following the curves of the leaves.

HYDRANGEA

The distinctive many-flowered spherical blooms of hydrangeas can be daunting to paint! A simple trick to add three-dimensionality to your flowers is to use several shades of the same colour, ranging from light to dark. I have gone with a violet-tinged blue and mixed five shades by combining it with varying amounts of white paint. With only these five shades, and by repeating a couple of simple steps several times, we can create a striking painting with real depth.

COLOURS

Five shades of the same blue, white.

Sketch

Draw a circle using a template or compass. That's it!

1

We are painting this with the idea that the light is coming from the top right, so starting with the first shade of blue (the lightest), paint several flower shapes across the top, right-hand third of the circle. It will make life easier if you paint these so that none of the flowers are overlapping. Hydrangea flowers have four pointed petals and are symmetrical when seen face-on. Flowers right at the edge of the circle will appear a little bit flattened due to the angle we are seeing them at, but some of the petals can extend a little bit beyond the perimeter of the circle.

2

Using the second shade of blue, paint shading lines extending from the centre of each flower outwards.

48

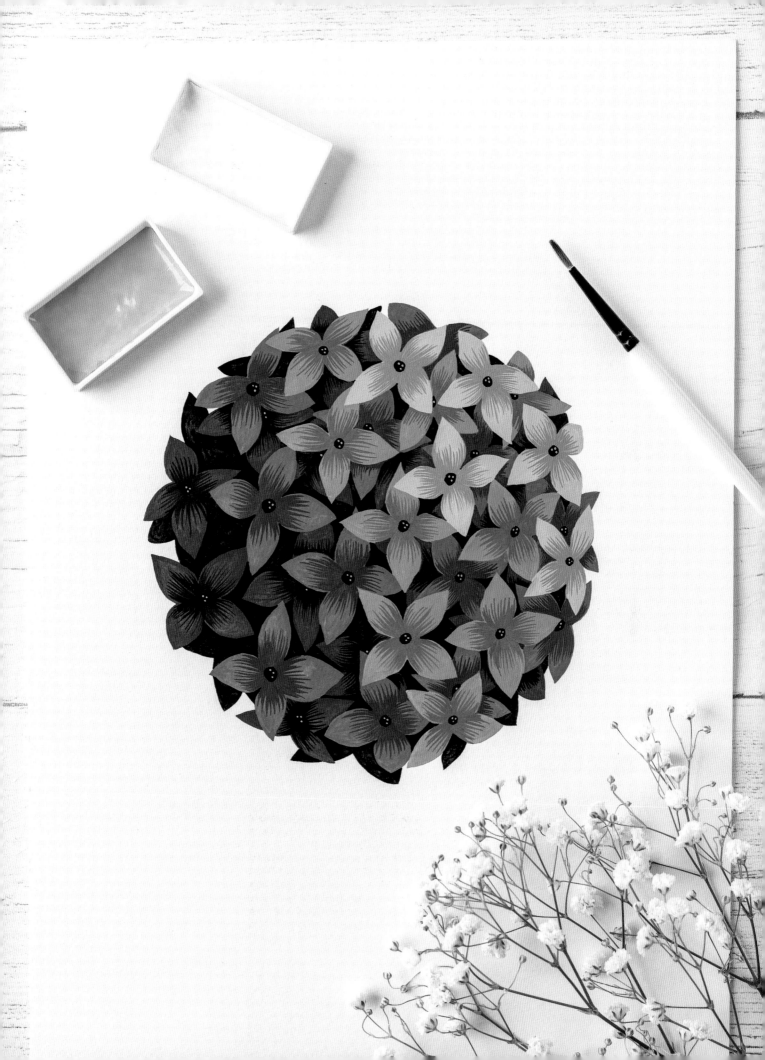

3

Continuing with the second shade of blue, paint more of the four-petalled flowers. Paint some of them behind the first layer of flowers from step 1, and some further across, stopping when you get to approximately halfway across the circle. Again, try not to paint any flowers of the same colour to be overlapping.

4

Now we're going to repeat the previous steps. On the flowers you have just painted in step 3, paint shading lines from the centre of each using the third shade of blue.

5

Again using the third shade of blue, paint more hydrangea flowers, again behind the flowers that you've already painted but this time going almost to the furthest edge of the circle (the part of our hydrangea sphere that is in the most shadow). By now you should be starting to fill in some of the gaps behind the lightest flowers.

6

Using the fourth shade of blue, paint shading lines at the centre of the flowers you painted in step 5.

7

With the fourth shade of blue, paint more hydrangea flowers across the whole circle, filling in most of the gaps behind the lighter flowers, and extending right to the darkest edge of our sphere.

8

Using the darkest blue, paint those same shading lines from the centre of the flowers you have just painted in step 7.

9

With the darkest blue, fill in any gaps between the lighter flowers with solid colour. Along the lower, darkest edge, add petal shapes to give the illusion of more flowers in the deepest shadow.

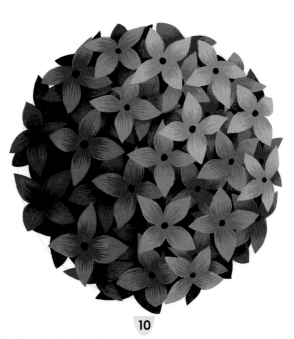

10

Still using the darkest blue, paint a small circle at every visible centre of a flower. Once that is dry, paint three tiny white dots on the centre of each flower. When your painting is completely dry, use an eraser to rub out any visible lines from your pencil sketch.

BLUE WILDFLOWER MEADOW

When I'm stuck for ideas but in the mood to paint, I love to choose one colour and paint an array of wildflowers in that colour. Wildflowers and their leaves are so varied and interesting that you can paint infinite combinations of them to create a delicate wildflower meadow pattern. You can keep adding to it, changing the shapes of the flowers and leaves, and really use your imagination. This project is a great exercise to practise painting different floral elements.

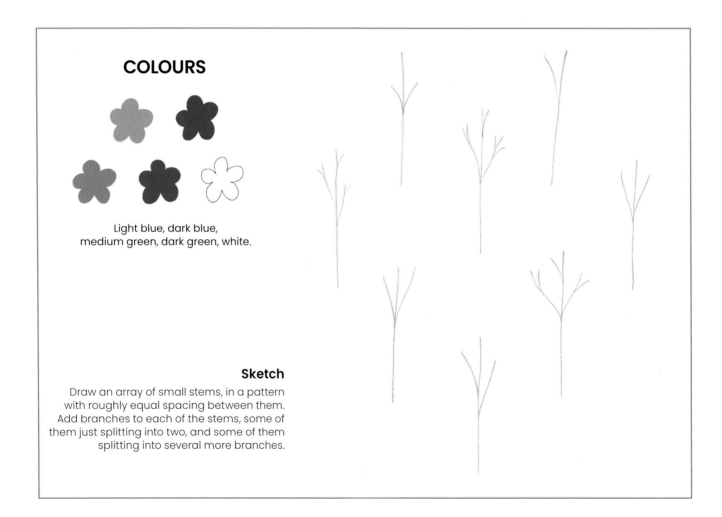

COLOURS

Light blue, dark blue,
medium green, dark green, white.

Sketch

Draw an array of small stems, in a pattern with roughly equal spacing between them. Add branches to each of the stems, some of them just splitting into two, and some of them splitting into several more branches.

1

Using the light blue paint, add some simple flower shapes around the tops of some of the small stems. These can be four-, five- or six-petalled; they can be pointed or round; they can be small or large – you are completely free to experiment here!

2

With the same colour, paint puffy cloud shapes at the tips of some of the other stems. The idea is that each is made up of many tiny flowers, so these can vary in shape and size.

3

On the last remaining stems, paint some spiky floral shapes by painting simple curved brush strokes extending outwards from a single point – I have done some large versions and small versions of these.

4

Time to add some shading and definition to your flowers using the dark blue paint. First, on the puffy shaped flowers, paint tiny dots over the lower half of each shape. On the tall, thin shapes, extend the dots along the right-hand edge, to give the illusion of shadow. On the very edge of the flower, where it would be in the most shadow, paint these dots closer together.

5

Still using the dark blue, paint the centres of the simple flower shapes, and add a few brushstrokes on top of the spiky flower shapes.

6

Paint over the stems with the medium green paint. You can add extra branching or twisting, overlapping stems here if you want to make them a bit more intricate, or keep the stems simple if you prefer. At the base of some of the flowers, I have added a little bulb shape where the stem meets the flower.

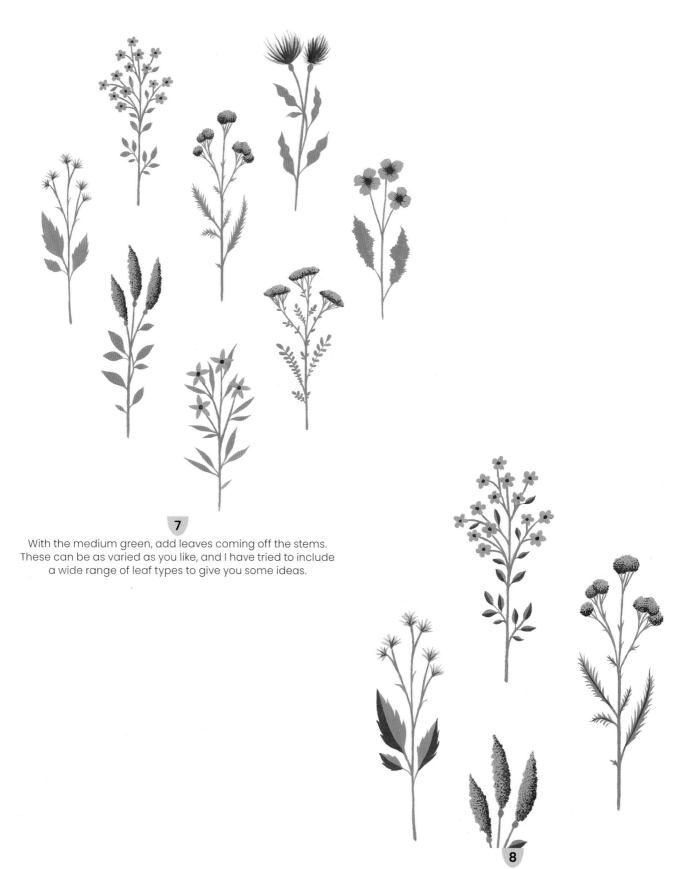

7

With the medium green, add leaves coming off the stems.
These can be as varied as you like, and I have tried to include
a wide range of leaf types to give you some ideas.

8

Paint half of each larger leaf with the dark green paint to
add depth.

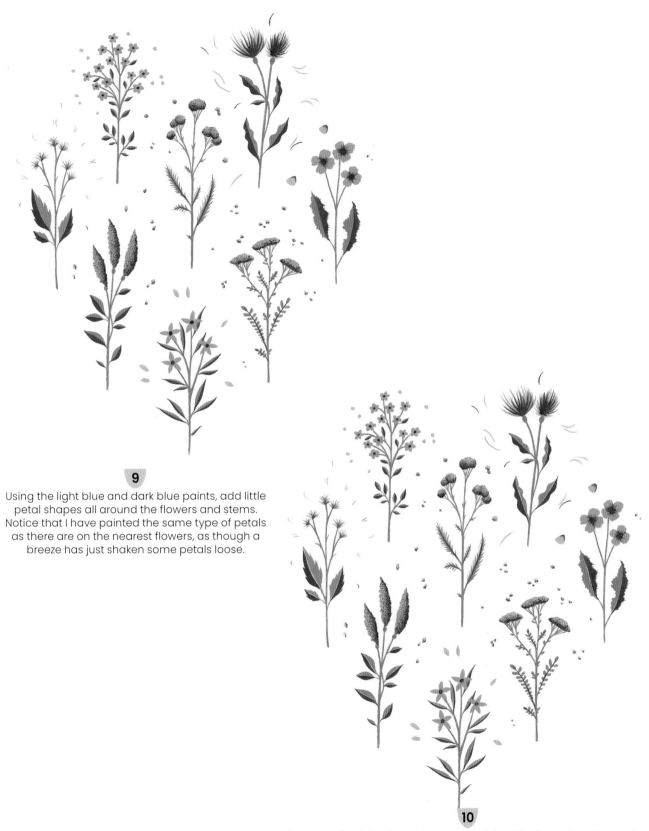

9

Using the light blue and dark blue paints, add little petal shapes all around the flowers and stems. Notice that I have painted the same type of petals as there are on the nearest flowers, as though a breeze has just shaken some petals loose.

10

For some final details, add some very thin white lines along the centre of some of the leaves, and some tiny white dots at the centre of some of the flowers.

LAVENDER FIELD

Here, we're going to paint a simple row of beautiful, classic lavender stems – think warm summer days in Provence; floral fields buzzing with bumblebees. The simplicity of a single stem of lavender also lends itself very well to being painted in bouquets and wreaths.

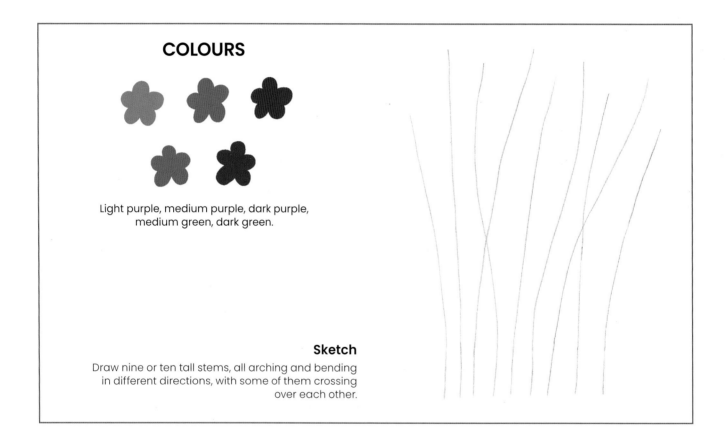

COLOURS

Light purple, medium purple, dark purple, medium green, dark green.

Sketch

Draw nine or ten tall stems, all arching and bending in different directions, with some of them crossing over each other.

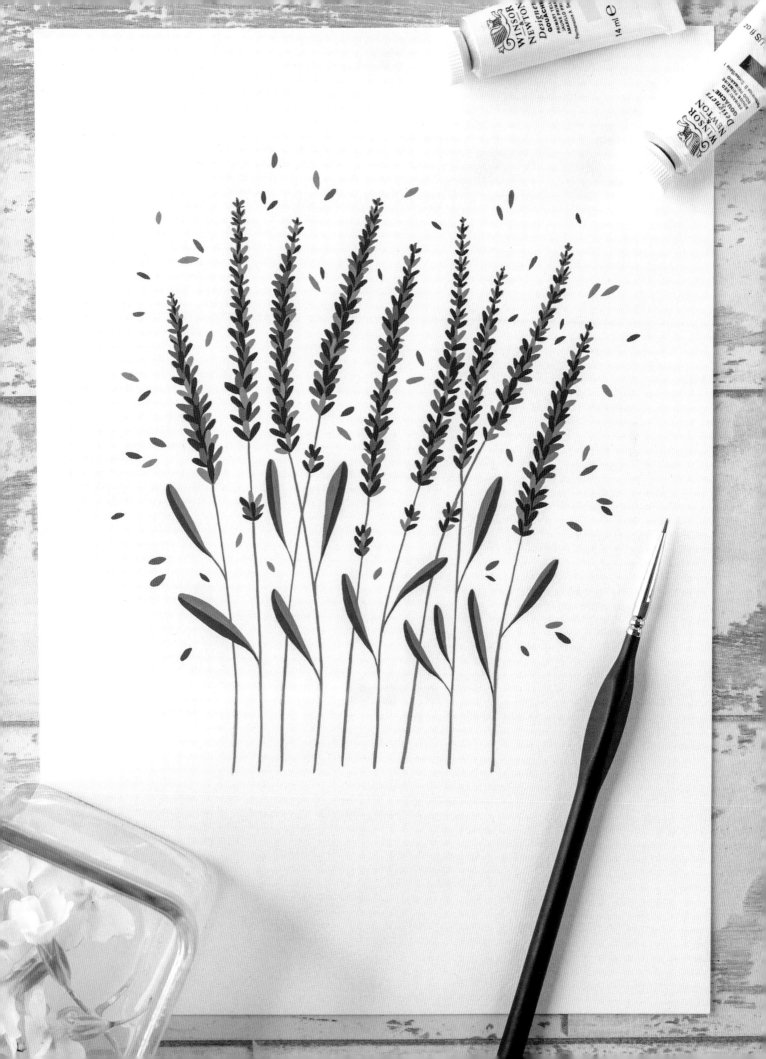

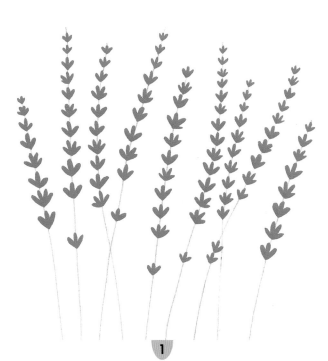

1

With the light purple, paint three- or four-petalled flowers all along the upper section of each stem. These should be roughly evenly spaced, and getting smaller as you go higher up the stem. On some of the stems, include just one or two little flowers a bit further down the stem.

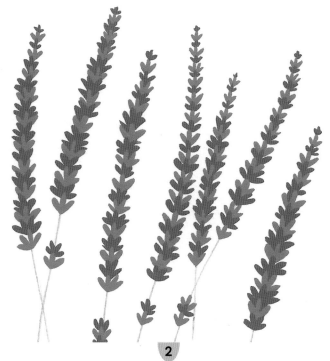

2

Using the medium purple, paint more flowers on the stems, filling in the gaps between those painted in the previous step. Where you have painted single flowers further down the stems, add just one or two more flowers next to them, so that there is still some stem visible between them and the main flowers.

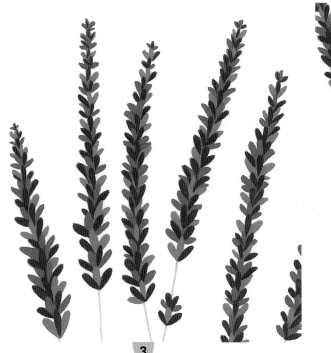

3

To add further dimension, paint one or two of the petals of each flower with the dark purple.

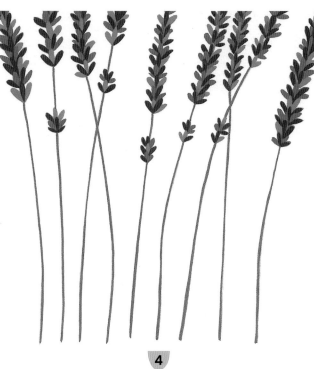

4

Paint thin, delicate stems with the medium green.

5

Still using the medium green paint, add one or two leaves to each stem. Lavender leaves are thin, elongated and pointing upwards with rounded ends.

6

Paint the lower half of each leaf with the dark green.

7

With the light, medium and dark purples, paint little lavender petals all around the stems.

A BOUQUET OF VIOLETS

I love painting bouquets, as you can keep them simple or make them as complicated as you like. You can also mix it up and include whichever flowers you like – for example, you could make this bouquet your own by painting daffodils instead of violets, or by adding sprigs of lavender. You can built up a bouquet with really simple layers and end up with an impressive finished painting.

COLOURS

Light purple, medium purple, dark purple,
white, yellow, orange,
medium green, dark green.

1

Paint the base colours of the flowers – yellow for the centre, and light purple for the petals.

Sketch

Draw five simple flower shapes close together in a group, each with five petals surrounding a small circular centre.

2

Let's add some detail to the centres of the flowers. Using the orange, paint tiny dots all over the yellow circles. Paint the dots closer together as you go further down, so that the orange is solid colour at the bottom of each circle.

3

Using the white paint, add three or four very fine white lines to each petal. These should follow the natural curve of each petal.

4

Add some shading lines to the petals using the medium purple, starting from the centre of the flower extending outwards, and starting from the outer edge of each petal extending inwards. Some of these lines should extend along the whole length of the petal, following the same curve as the white lines.

5

To create depth, use the dark purple to add a few more shading lines at the centre of the flowers, not extending quite as far as in the previous step.

6

Now we're going to create the bouquet shape by painting the stems with the medium green. The stems should all cross over at a single, central point. I'd recommend drawing these in with pencil first if you are not confident painting freehand.

Now we're going to add some wavy leaves to the stems, using the same medium green. You can paint these anywhere along the stems, with some of them disappearing behind the flowers. Vary the sizes of the leaves for a more natural-looking arrangement.

Using the dark green, paint the lower half of each leaf to add depth.

Using the dark green, add some filler foliage to the bouquet. Paint thin stems behind the flowers, crossing over at the same point and extending further outwards than the flowers and leaves you've already painted. Add lots of small leaves along the stems. You can keep this step fairly simple or make it really intricate by adding more leaves.

Add a very fine vein along the centre of each leaf using the white paint.

PRESSED WILDFLOWERS

Continuing with my love of wildflowers, I'm now going to show you
how I paint a simple pressed flowers and leaves composition. You can
adapt this method and paint the flowers in your favourite colours – I've
gone for the primary colours of red, blue and yellow.

COLOURS

Medium pink, red, yellow, dark brown,
light blue, medium green, dark green.

Sketch

Draw three curved stem shapes, going in
different directions across the page.

1

Starting with the leftmost stem, paint a spiky flower shape
with the medium pink paint by painting curved brushstrokes
outwards and upwards in all directions from the very top
of the stem.

2

Repeat the previous step with the red paint over the top of the
pink spiky flower shape.

3

Moving on to the second stem, paint simple five-petalled yellow flower shapes all around the top of the stem.

4

Paint a small dark brown dot in the centre of each yellow flower.

5

Around the third stem, paint many tiny heart shapes using the light blue. The pointed end of each heart shape should be pointing towards the stem.

6

Paint the stems using the medium green paint. At the base of the red flower, paint a little bulb shape. For the other two, the stem will branch into many sections, so that each tiny flower joins up to the main stem.

7

Add leaves to each stem, using the medium green paint. These can vary in shape and size – I have gone for longer, thinner leaves on the red flower; larger notched leaves on the blue; and long feathery leaves on the yellow.

8

In the spaces between the flower stems, paint some sprigs of leaves using the medium green paint. Start with a curved line, and then paint several leaves growing off either side of it and one leaf at the end. The leaf at the end will be the largest, and they get progressively smaller as down the stem. I have painted some of the leaves with notched edges, and some with smooth edges. I drew these in with pencil first to be sure I was happy with the placement.

9

Using the dark green, paint half of each leaf.

10

In any remaining significant spaces, paint tiny sprigs of leaves with the dark green paint. These are exactly like the sprigs of leaves you painted in step 8, just much smaller!

11

Using the pink, red, yellow and blue colours that you used for the flower petals, paint some more loose petals, filling in empty spaces with little bits of colour. Note that while these are scattered across the entire page, I have painted most of the blue petals near the blue flowers, yellow petals near the yellow flowers and red/pink petals near the red flower.

DRIED AUTUMNAL FLOWERS

Dried flowers provide a wonderful opportunity to paint using a completely different range of colours. Rather than greens, pastels and bright hues, we'll be using an autumnal palette of reds, browns and yellows. This is a simple painting of four dried stems, but you could use a similar colour palette to create a bouquet or wreath.

COLOURS

Light creamy yellow, mustard yellow, orangey-brown, dark brown.

Sketch
Draw four simple stems, fanning outwards from each other.

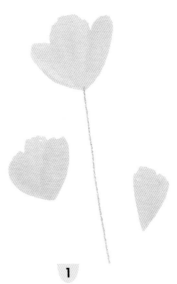

1

Starting with the leftmost stem and using the light creamy yellow, paint a few flattened flower shapes around the top of the stem.

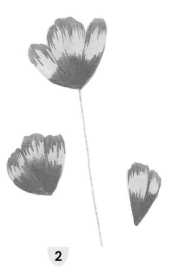

2

Using the mustard yellow, paint the lower half of each petal. With the same colour, paint shading lines of varying lengths along the top edge of the petals extending downwards.

3

Paint in the stem and leaves using the orangey-brown. You can improvise here, adding leaves wherever you like – make the stem look more interesting by branching, curving and overlapping the stems and leaves. At the base of each flower, paint a small bulb at the top of the stem, and add a few short shading lines to the very bottom of the petals.

4

Moving on to the second flower, paint small orangey-brown heart shapes all around the upper half of the stem, pointing towards the stem.

5

Using the dark brown, paint in the stem and leaves. Join each heart shape to the main stem with thin, branching lines. Again, you can go freestyle with the leaves – I've gone for a more feathery, spiky leaf shape as these are common in dried foliage.

6

Around the top half of the third stem, paint small dark brown spiky flower shapes.

7

Add a stem and leaves using the mustard yellow, again overlapping and curving branches for a more natural look. I have painted the same type of long, thin leaves as in the first stem.

8

At the top of the final stem, using the light creamy yellow, paint a couple of larger spiky floral shapes.

9

Paint the final stem using the orangey-brown, then add the same spiky, feathery leaves that you painted in step 5.

10

Add some little details as a final step: I have used the dark brown to add shading to the leaves of the left-hand stem, orangey-brown on the leaves of the third stem, and tiny dark brown dots at the centres of the right-hand flowers.

TANSY

The pretty yellow tansy is a herbaceous flower also known as bitter buttons. I love its button-shaped flowery heads and feathery leaves; they look beautiful in autumnal arrangements. This simple little painting uses only three colours to great effect.

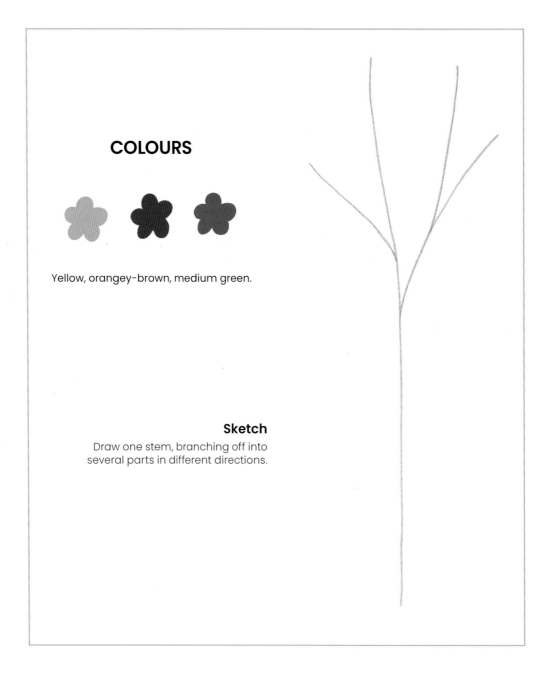

COLOURS

Yellow, orangey-brown, medium green.

Sketch
Draw one stem, branching off into several parts in different directions.

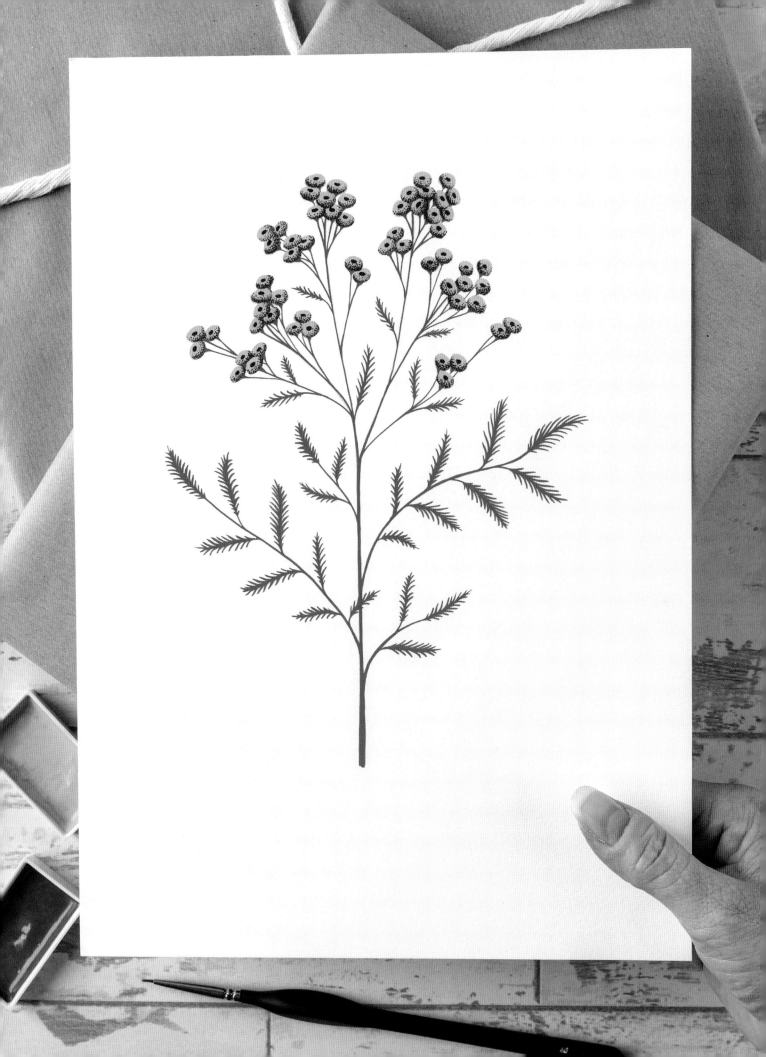

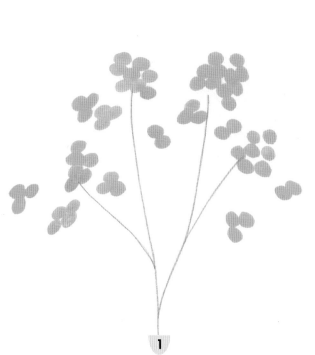

1

First, let's paint the flower shapes. Paint yellow ovals around the top of the branch stems, in overlapping groups of two or more.

2

Using the orangey-brown, paint tiny dots across the lower third of each oval. Right at the bottom of each oval, paint the dots so close together that the colour is almost solid.

3

Paint a small orangey-brown oval at the centre of each flower.

4

Join each oval flower to the stem with thin, branching green lines, painting the stem a little bit wider where the stem meets each flower.

5

Paint the main stem with medium green.

6

Now we're going to add some branching, feathery leaves. Paint several thin green leaf-stems of varying lengths growing off the main stem. Each of these stems will have many leaves growing off it, so leave a bit of space in between them.

7

Along either side and at the very end of the leaf-stems, paint delicate feathery leaves growing off the stems. The feathery strokes should get smaller towards the ends of the leaves.

8

Repeat the previous step along each of the leaf-stems, and also add a few individual feathery leaves coming off at various points of the main stem.

SPRINGTIME DAISIES

Some may see daisies as a weed but I think they're one of the prettiest delicate springtime flowers. I love seeing them pop up as the weather turns warmer. I painted this little row of daisies, with some added foliage in the background, to evoke feelings of a bright spring morning. White flowers can seem daunting to paint, but it's not too tricky using a very light grey.

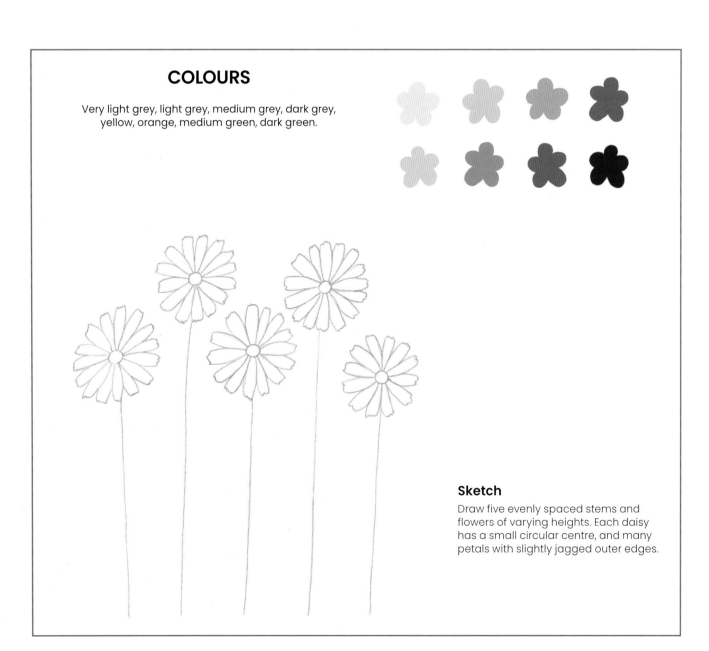

COLOURS

Very light grey, light grey, medium grey, dark grey, yellow, orange, medium green, dark green.

Sketch

Draw five evenly spaced stems and flowers of varying heights. Each daisy has a small circular centre, and many petals with slightly jagged outer edges.

1

Using the medium pink, paint pointed shapes at the end of each stem. Each of these shapes will be made up of many tiny flowers, so make the edges jagged and irregular. At the bottom and top of some of the shapes, paint some additional small shapes along the stem.

2

Add some shading to the shapes, using the dark pink. Paint tiny dots all over, making them more condensed at the lower centre of the shapes, and more spread out towards the edges.

3

Repeat the previous step using the purple paint, again painting the dots closest together at the centre lower half of the shapes.

4

Paint in the stems using the medium green paint. Make sure to paint the stem to join up to each of the flower shapes, including the smallest ones painted at the top and bottom of the main shape.

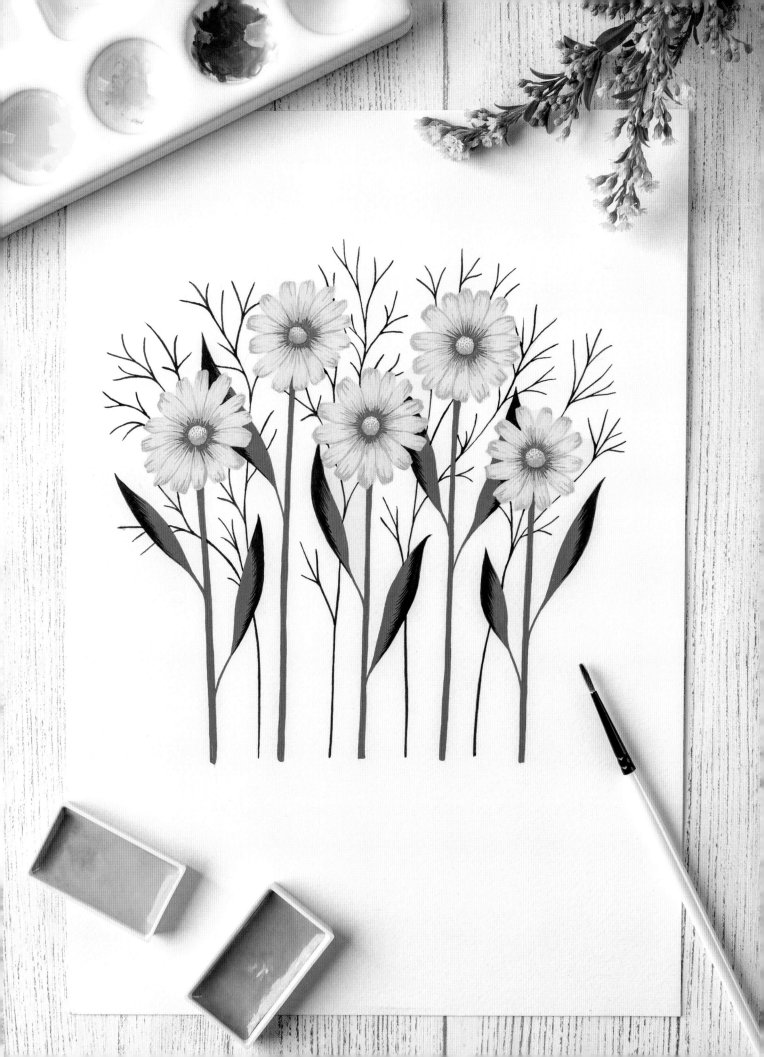

1 Paint in the main colours of the flowers – yellow for the centre of the flower, and very light grey for the petals.

2 Using the orange, paint tiny dots all over the centre of each flower. Continue stippling over the lower half until it is completely solid orange.

3 Add shading lines to the flower petals using the light grey paint. These should start at the centre of the flower (extending outwards) and at the outer edges of the petals (extending inwards). These are quite subtle as the shades of grey are very close to each other, but are important to add depth.

4 Repeat the previous step with the medium grey, not extending the shading lines so far this time.

5

With the dark grey, paint short shading lines at the centres of the flowers only. This is to add depth and make the yellow centres of the flowers pop!

6

Paint in the stems with the medium green, adding one or two elongated pointed leaves to each stem.

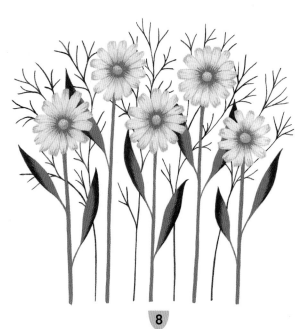

7

Add some shading to the leaves with the dark green – starting at the pointed end of the leaves and continuing down one edge, paint fine lines pointing downwards towards the leaf's base.

8

In between each stem and behind the daisies, use the dark green to paint a very thin stem that branches into many tiny stems. These should be visible between the daisies and grow taller than the flowers – you can make these as simple or intricate as you like!

HEATHER

Heather flowers, which bloom in late summer on the moors of Europe, have a unique structure and appearance. I think their slender stems, tiny leaves and bright purple flowers make for a really striking painting on their own, and they're also a great one to paint into bouquets as a filler flower.

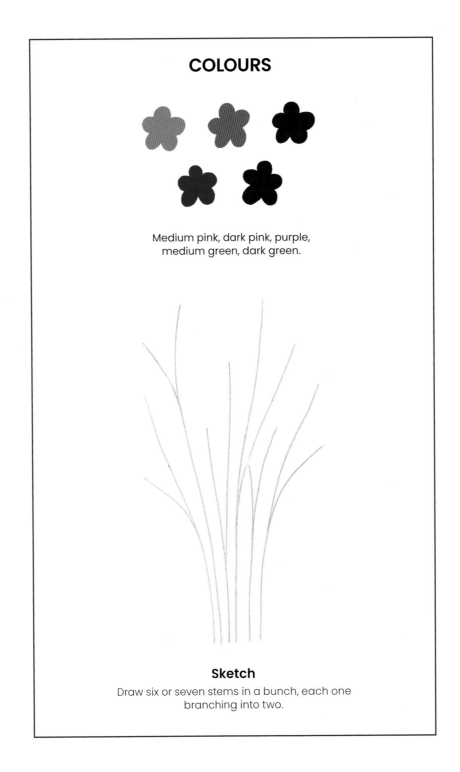

COLOURS

Medium pink, dark pink, purple, medium green, dark green.

Sketch

Draw six or seven stems in a bunch, each one branching into two.

5

Still using the medium green paint, add a few branches of small, wavy leaves coming off the main stems.

6

Add more medium green leaves along the main stems. These leaves grow all the way along both sides of the upper stems, and grow more sparsely at the bottom of the stems.

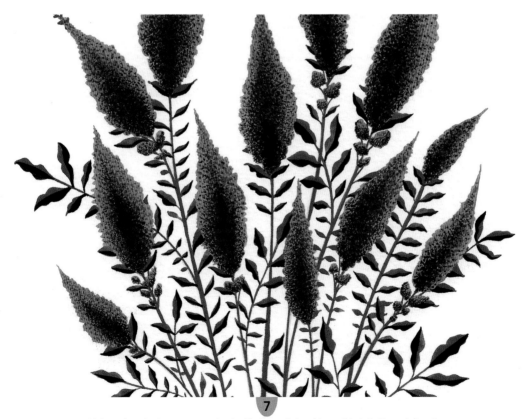

7

Using the dark green, paint half of each leaf to add detail and depth.

WHITE FLORAL WREATH

We're now going to look at painting a simple wreath. It's a wonderful design to learn to paint, as it can be used beautifully for greeting cards or personalized gifts – it's my go-to for a newborn baby or christening gift, with the name and birthday of the bundle of joy written in the middle! Wreaths can be built up to be very complex, but we're going to start with a nice simple one to learn the basics.

COLOURS

Very light grey, light grey, medium grey, black, very light green, light green, medium green, dark green.

Sketch

Draw a circle (you can use a compass or a stencil – I drew around a small plate). Draw three five-petalled flowers with wavy edges along the bottom left of the circle. The outer petals of the flowers should be just touching the circle.

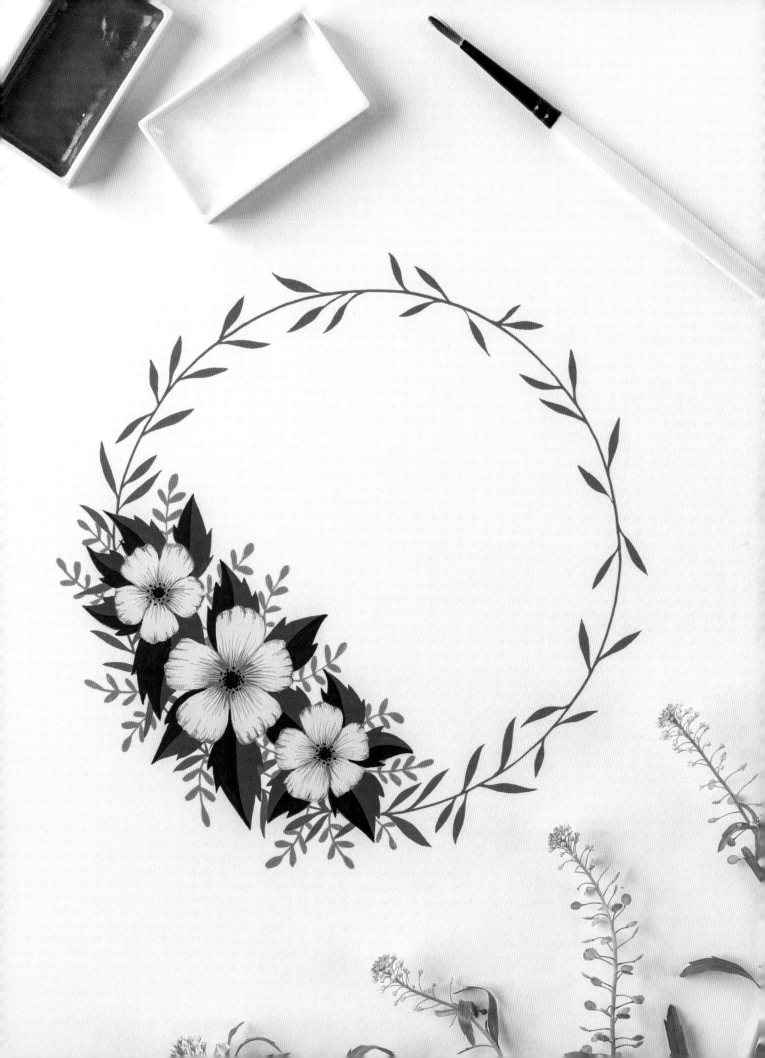

1

Paint the three flower shapes very light grey.

2

Add shading lines to the petals using the light grey paint, starting at the centre and extending outwards, and starting at the outer edges of the petals extending inwards.

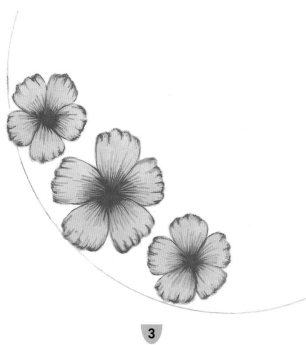

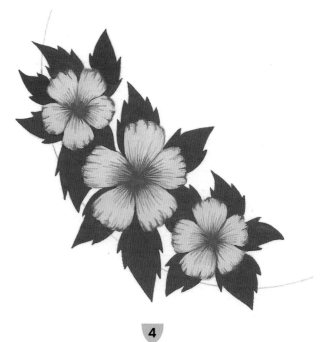

3

Using the medium grey, add further shading lines on top of the previous ones, not extending quite so far along the petals this time.

4

Add some large, notched leaves growing from behind each flower, using the medium green paint. I have painted the leaves so that they don't overlap with each other, for simplicity.

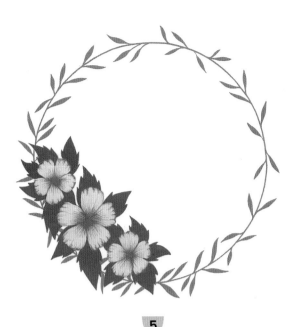

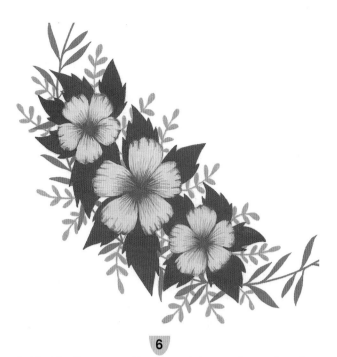

5

Paint the circle using the light green paint. All along the inside and outside of the circle, paint small slender leaves. These can be growing in both directions (clockwise and anticlockwise) for a more natural effect.

6

Behind the flowers and leaves, paint some tiny sprigs of leaves using the very light green, growing in all directions.

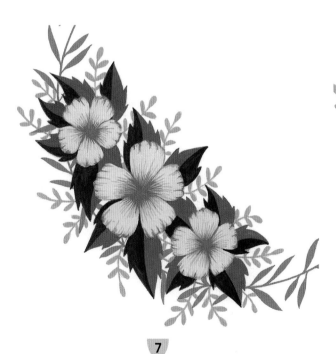

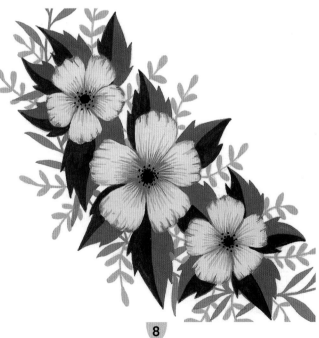

7

Paint half of each of the larger leaves dark green.

8

At the centre of each flower, paint a small solid black circle surrounded by tiny black dots.

LARKSPUR

Larkspur, or delphinium, are beautiful bright blue flowers that grow in countryside gardens. I love painting these; their many flowers on a single stem look so pretty and delicate, and I am always drawn to blue flowers.

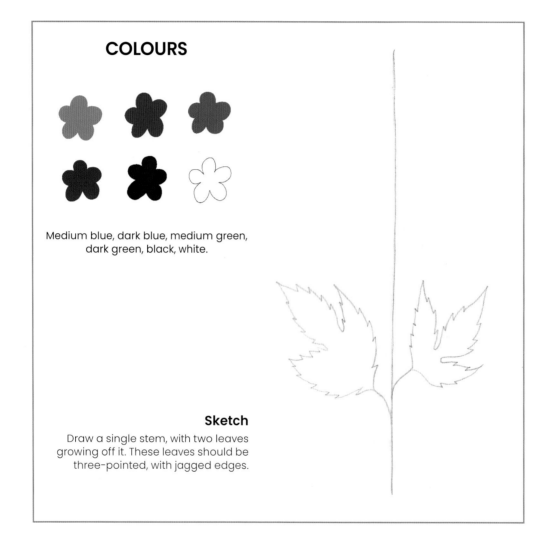

COLOURS

Medium blue, dark blue, medium green, dark green, black, white.

Sketch

Draw a single stem, with two leaves growing off it. These leaves should be three-pointed, with jagged edges.

Along the top half of the stem, paint many small five-petalled flowers, some overlapping, using the medium blue paint.

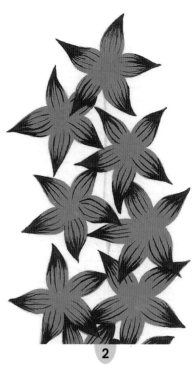

Using the dark blue and starting at the outer point of the petals, paint shading lines extending towards the centre of each flower. Some of these lines should be almost the entire length of the petals.

Paint three overlapping white circles at the centre of each flower.

On top of the white circles, paint three black dots at the centre of each flower.

5

With the medium green, paint the stem and leaves. Make sure to paint the stem wherever it is visible in gaps between the flowers.

6

Still using the medium green, join the flowers to the main stem with a thinner stem, and add more leaves – these should be long slender leaves growing upwards. Most of these should be growing from the stem near where the flowers are, with just a couple on the lower half of the stem.

7

Add shading to the leaves using the dark green paint. On the large leaves, paint shading lines starting at the outer edge and directed towards the base of the leaf. On the small leaves, just paint the lower half in dark green.

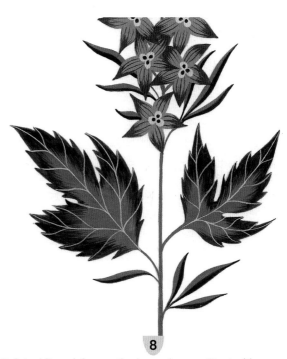

8

Paint white veining on the larger leaves. Start with a central line branching into the three points of the leaf, and then add further branches coming off those.

SOFT PINK BOUQUET

This type of bouquet is a little bit more modern, looser and more natural than the one we painted previously. I really enjoy painting this kind of composition freehand, as you can add continue adding layers of different flowers, leaves and foliage to make it entirely unique, just like a real bunch of flowers!

COLOURS

Light pink, medium pink, dark pink, dark brown, light green, medium green, dark green, burgundy, white.

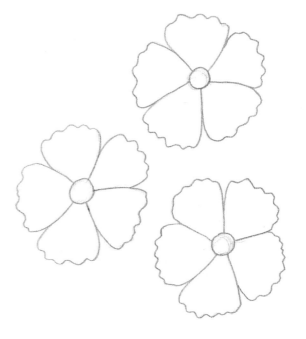

Sketch

Draw three five-petalled flowers, in a roughly triangular configuration, with wavy edges and a small circle at the centre of each.

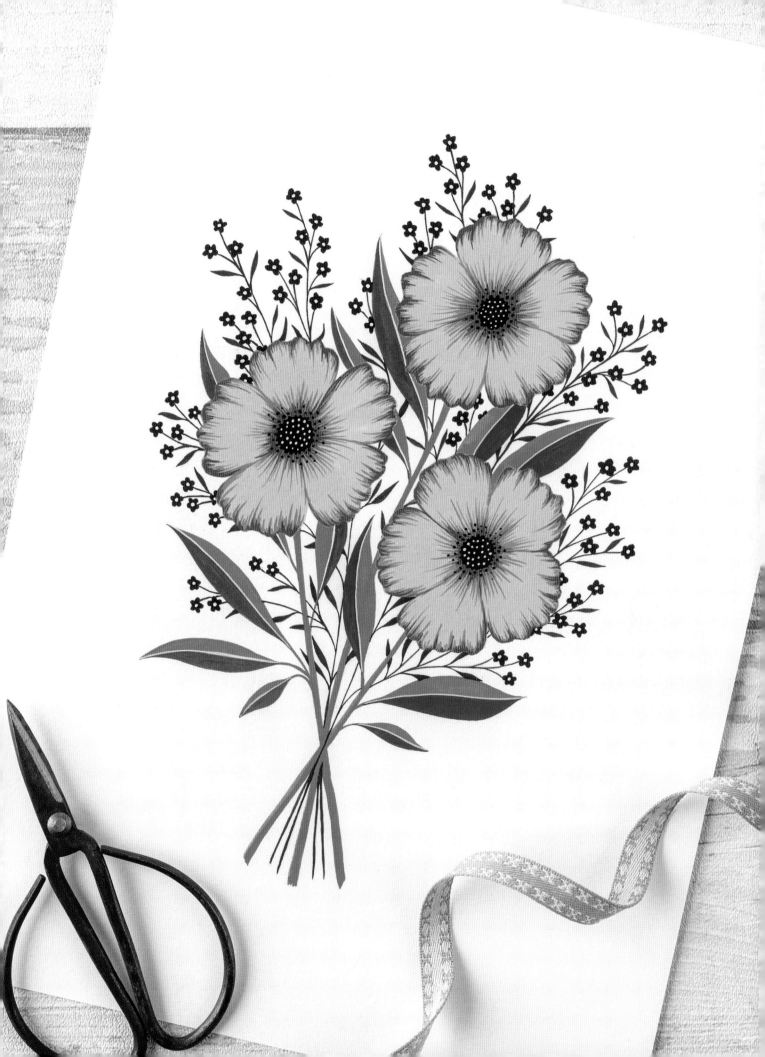

1

Paint the petals of the flowers light pink.

2

Add shading lines with the medium pink, starting from the centre of the flower directed outwards, and from the outer edge of the petals directed inwards.

3

Repeat the previous step, adding further shading lines with the dark pink, not extending them quite so far along the petals this time.

4

Paint the centre of each flower dark brown, and add tiny dark brown dots all around the central circle.

5

Using the lightest green, paint the stems of the flowers. The three stems should cross over at a single point. Add elongated, pointed leaves growing off each of the stems, some of them going behind the flowers.

6

Paint the lower half of each of the leaves with the medium green to add three-dimensionality.

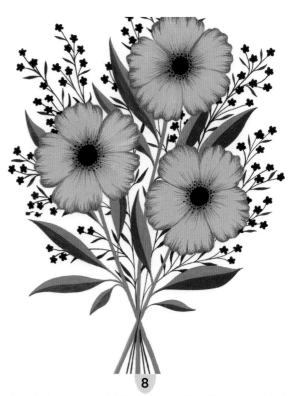

We're now going to add some smaller flowers to the bouquet. Using the burgundy, paint tiny five-petalled flowers all around and behind the large flowers.

With the dark green, paint the stems of the tiny flowers behind the main stems. These should cross over at the same point as the main stems, and branch off further up to join the burgundy flowers. Add lots of tiny leaves to these stems.

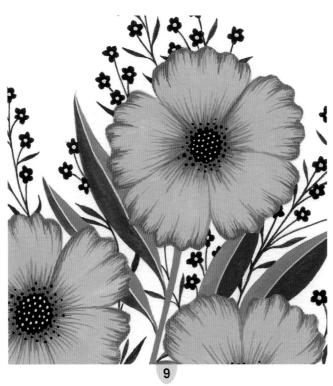

Add some final details using the white paint – I have painted a white vein along the centre of the large leaves, a tiny white dot at the centre of each burgundy flower, and many tiny white dots at the centre of the large flowers.

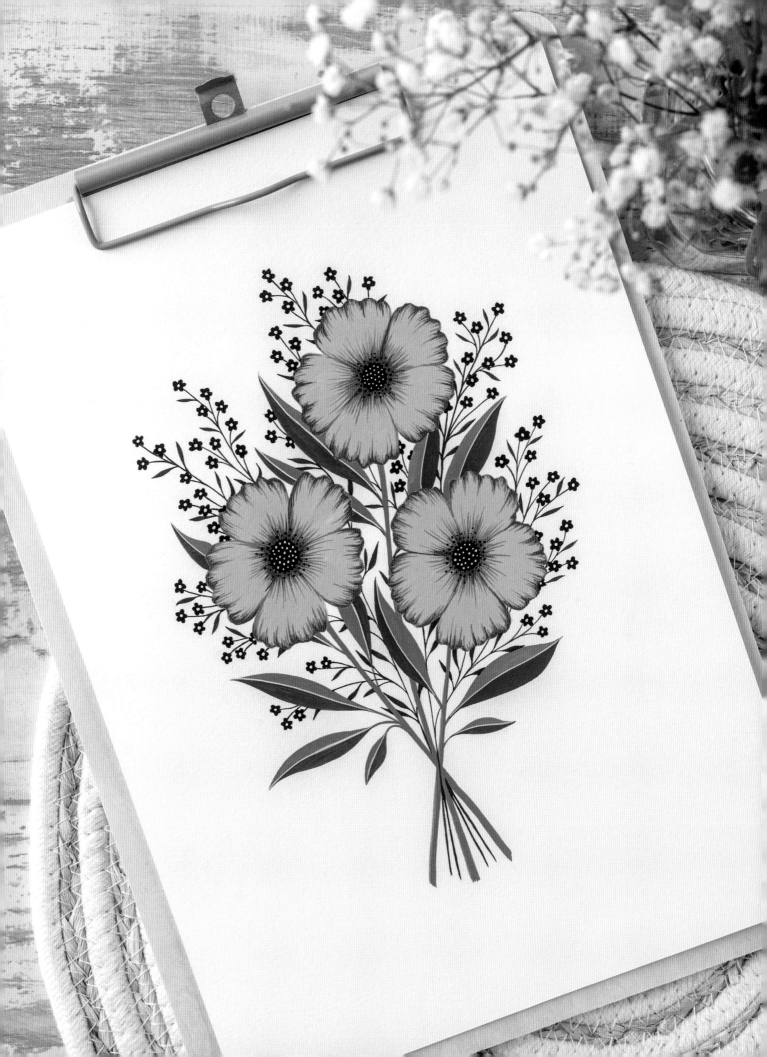

A BUNCH OF BLUEBELLS

English bluebells, with their distinct bell-shaped flowers, are a staple of spring illustrations for me. I love painting them in combinations with other spring florals like daffodils, cherry blossom and tulips. Here, I will show you how to paint a simple bunch of bluebells – once you've got the hang of that, why not try painting them into a spring bouquet of your own?

COLOURS

Light blue, medium blue, dark blue, medium green, dark green.

Sketch
Draw four stems, arching outwards from each other. From about halfway up each stem, draw little evenly-spaced stems branching off. These will be where the bluebell flowers grow.

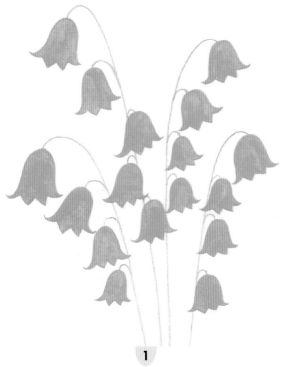

1

Using the light blue, paint the bluebells at each stem tip – each bluebell flower is bell shaped, with several points at the bottom.

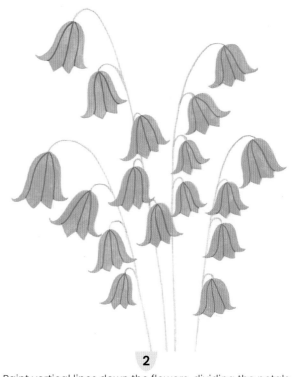

2

Paint vertical lines down the flowers, dividing the petals and following the curve of the bell shape, with the medium blue paint.

3

Still using the medium blue, add shading lines to the flowers, starting from the top going downwards, and starting from the bottom going upwards.

4

Add further shading lines using the dark blue paint, at the top of each flower and at the tip of each point at the bottom.

5

At the bottom of the stems, paint some long thin leaf shapes – almost like large blades of grass – using the medium green paint.

6

Paint lines along these leaves with the dark green, following the curve of each leaf.

7

Now let's move on to the stems. Using the dark green, paint the stems of the bluebells and a little spiky shape where each flower meets the stem.

8

Add lots of tiny leaves all the way along the bluebell stems, using the dark green paint.

FLAMINGO FLOWER

Tropical plants offer a completely different type of flower – they tend to have larger petals, unusual shapes and bright, vibrant colours – which makes them really fun to paint! The anthurium, also known as the flamingo flower, is immediately recognizable with these distinctive shiny heart-shaped flowers.

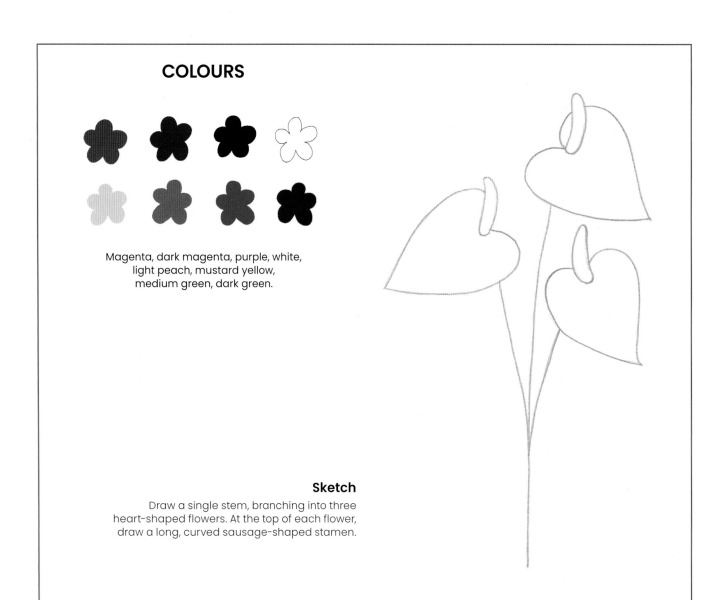

COLOURS

Magenta, dark magenta, purple, white, light peach, mustard yellow, medium green, dark green.

Sketch

Draw a single stem, branching into three heart-shaped flowers. At the top of each flower, draw a long, curved sausage-shaped stamen.

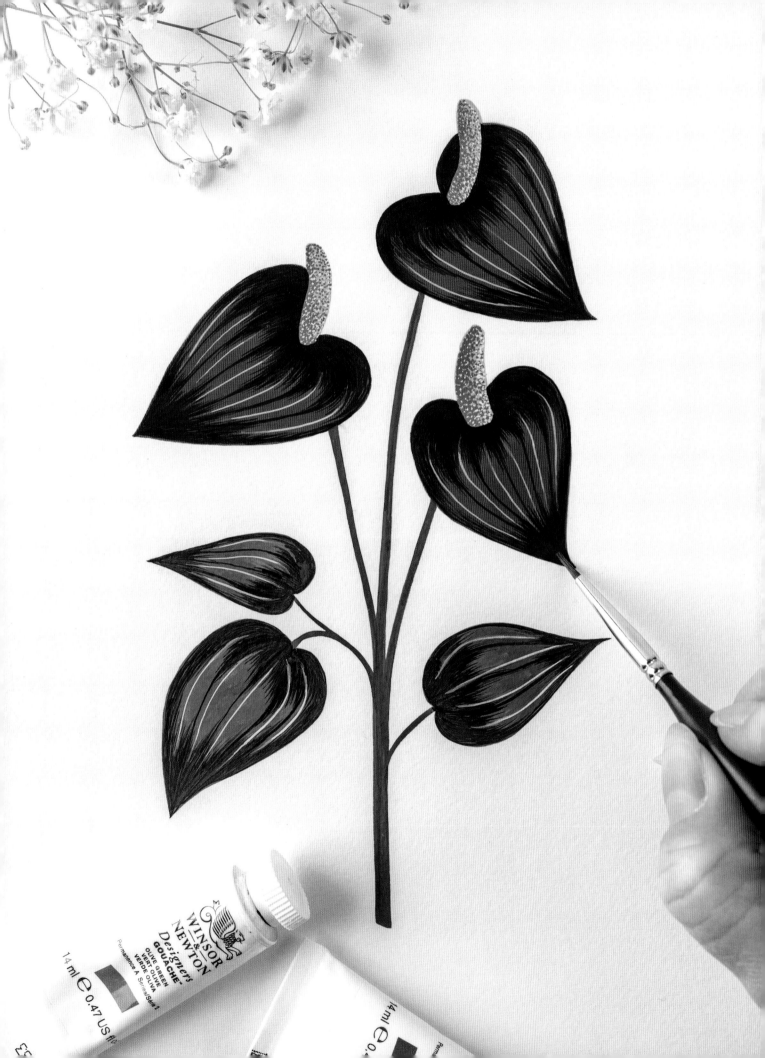

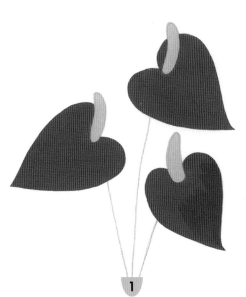

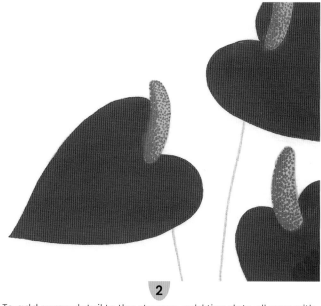

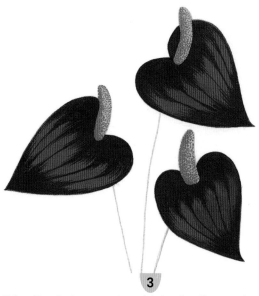

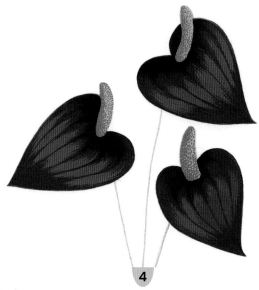

1

Paint the main base colours of the flowers – magenta for the flower itself, and light peach for the stamen.

2

To add some detail to the stamen, add tiny dots all over with the mustard yellow, painting them closer together along the left-hand side to give the illusion of deeper shadow.

3

Using the dark magenta, add shading lines to the flowers. First, paint several lines that extend the entire length of the flower, following the curve of the heart shape. Next, paint shorter lines, starting at the top of the flower extending downwards, and starting at the bottom of the flower extending upwards.

4

Add further shading lines using the purple paint, starting at the base of the stamen and spreading outwards from there.

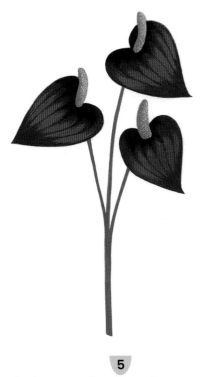

5

Paint the stem using the medium green paint.

6

Add a few heart-shaped leaves growing off the main stem, painting them with the medium green. Notice that the shape of the leaves mirrors the shape of the flowers.

7

With the dark green paint, add shading lines to the leaves in exactly the same way as we did on the flowers in step 3.

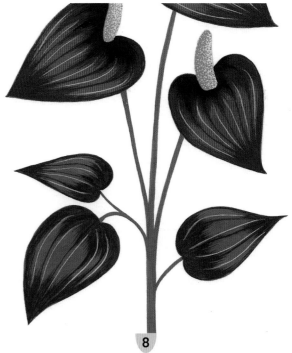

8

Finally, to add shine, paint thin white lines between the dark shading lines of the flowers and leaves, again following the curve of the heart shape. Also paint a few white dots along the right-hand side of the stamen to add highlights.

FESTIVE WREATH

Time for another wreath! This one is a little bit more intricate than the white wreath on page 88, but if you take it step by step it is actually deceptively simple, as it is just made up of several layers of foliage. In my mind, the red flowers and berries make this a little bit Christmassy, but you could easily adapt it by using different colours and swapping the berries for tiny flowers to make it appropriate for any season.

COLOURS

Red, black, brown, white,
light green, medium green, dark green.

Sketch

Draw a circle using a compass or a round plate/bowl as a template. Draw three six-petalled flowers equally spaced on the circle – I did this by imagining the circle as a clock and drawing the flowers at 3, 7 and 11 o'clock.

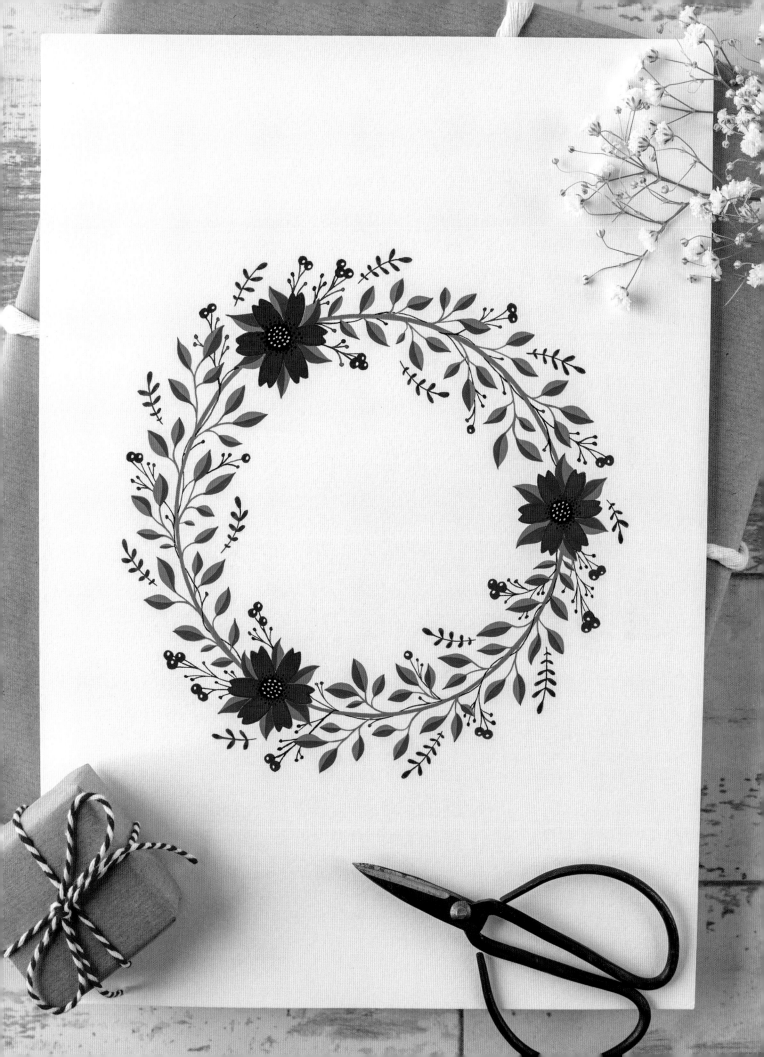

1

Paint the flowers using the red paint.

2

Paint the centre of the flowers as a solid black circle surrounded by tiny black dots.

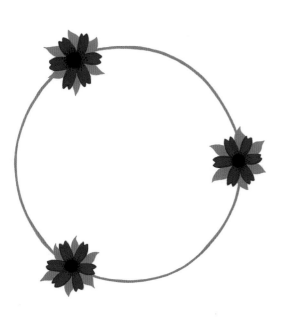

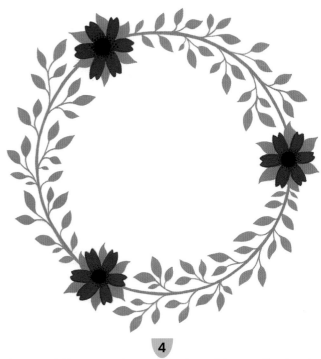

3

Use the lightest green to paint leaves behind the red flowers – one leaf in between each pair of petals. Use the same green to paint the circle of the wreath.

4

Time to add leaves to the wreath – lots of them! Still using the light green, paint leaves of varying sizes all along the circle, inside and outside, all growing in a clockwise direction. Paint some leaves growing directly off the main wreath, and some growing off separate little stems in groups of three or four.

5

Add depth to the leaves by painting one half of each leaf using the medium green.

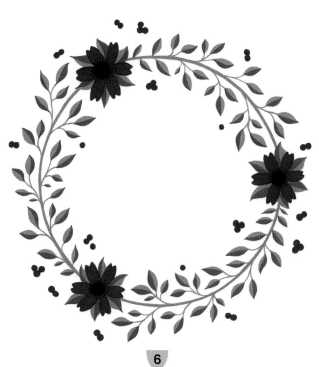

6

Let's add some berries to the wreath. Paint little groups of two or three red circles around the outside and inside of the wreath.

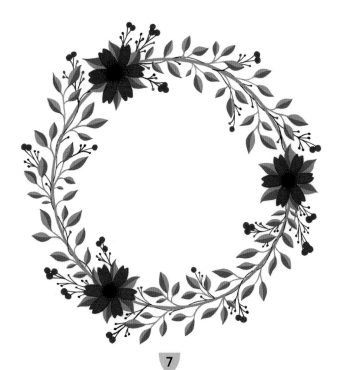

7

With the brown paint, add thin stems to the berries and join these to a thin stem which intertwines with the main green circle. Add little twigs near the berries that branch off and end with a tiny brown dot. Paint these so that the berries and twigs are growing off the circle in a clockwise direction.

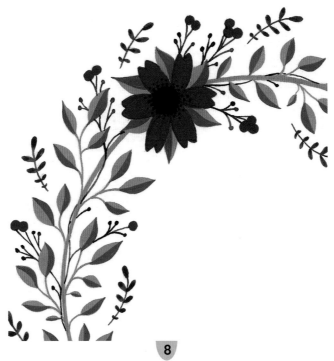

8

Paint some tiny sprigs of leaves, using the dark green paint, all around the circle (inside and outside). Again, these should all be growing in a clockwise direction, but mine are not attached to the main wreath.

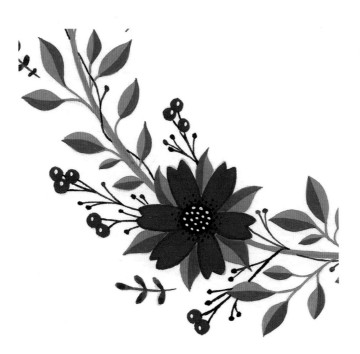

9

Add some final details using the white paint – paint a tiny white dot on each of the berries to make them look shiny, and paint tiny white dots at the centre of each flower.

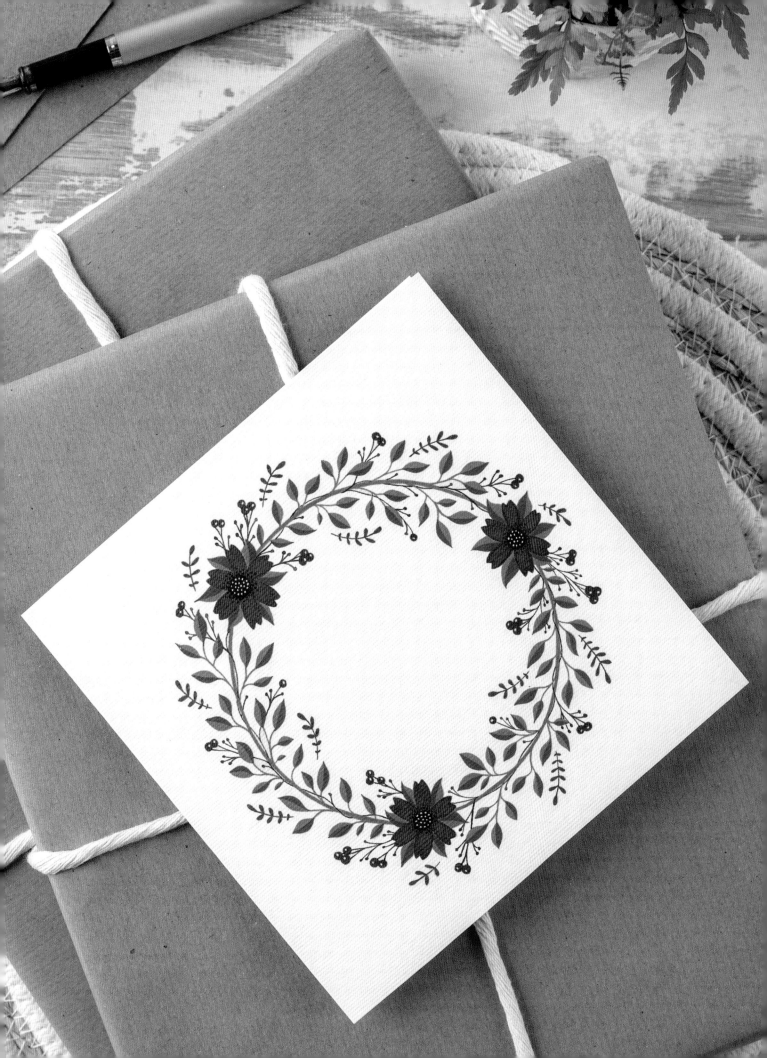

RAINBOW WILDFLOWERS

This tiny rainbow wildflowers painting is a little whimsical piece, not really based on any real flowers, but a fun, simple and relaxing piece to paint! When I'm in the mood to paint but lacking inspiration, I love painting bunches of tiny flowers like this, practising intertwining stems and leaves, and experimenting with different colour combinations.

COLOURS

Red, orange, yellow,
light blue, lilac, pink, black,
light green, medium green, dark green.

Sketch

Draw seven stems in a row, starting close together at the bottom and leaning outwards from each other towards the top.

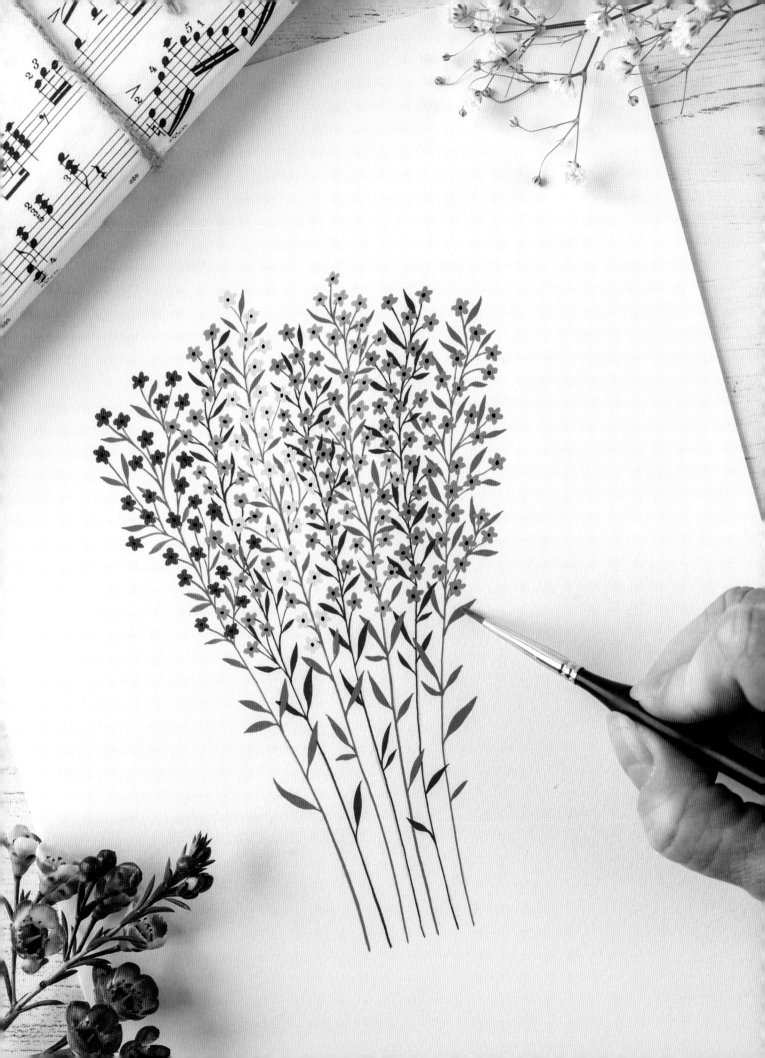

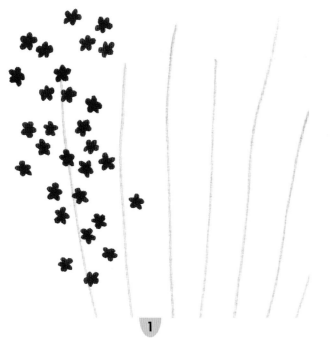

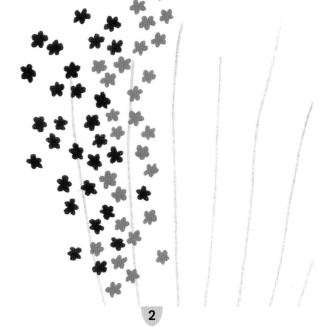

1

Starting with the leftmost stem, paint tiny five-petalled red flowers all around the upper stem. Some of them should be a little bit further away, even further than the second stem, as we are going to paint the flowers overlapping.

2

Moving on to the second stem, paint the same type of tiny flowers in orange. Again, paint some of these further away from the stem, so that the red and orange flowers are intermingled with each other.

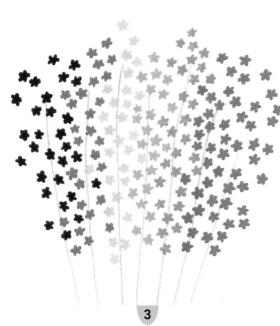

3

Repeat steps 1 and 2 along the rest of the stems – the third stem will have yellow flowers, the fourth light green, the fifth light blue, the sixth lilac and the seventh pink.

4

Using the medium green, paint the leftmost stem, branching it out and joining it to every red flower you've painted.

5

Add medium green leaves to the stem, smaller leaves near the flowers and larger leaves further down the stem.

6

Moving on to the orange flowers, repeat steps 4 and 5 by painting the stem and leaves using the dark green paint this time, making sure to join the stem up to every orange flower.

7

Continue painting in the stems and leaves, alternating medium green and dark green for each flower stem. Go one by one, making sure that all the flowers are joined up to the correct stem.

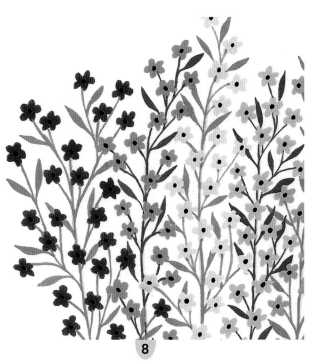

8

Paint a tiny black dot at the centre of each flower.

FLORAL CIRCLE

I paint a lot of my floral pieces in circular compositions – I love how they look: a modern alternative to a classic wreath. This one features yellow and dark red flowers loosely based on tickseed flowers, but you could create a similar composition using any other flower as the central focus. The trick is to pencil in the circle very lightly first, so that you can create a very crisp outline, and then erase the circle at the end.

COLOURS

Mustard yellow, dark mustard yellow, deep burgundy, white, light green, medium green, dark green.

Sketch

Draw a circle – pencil this in lightly so that you can erase it at the end. At the centre of the circle draw two eight-petalled flowers and two tear-shaped buds in between the flowers.

1

Paint the flowers and buds using the mustard yellow.

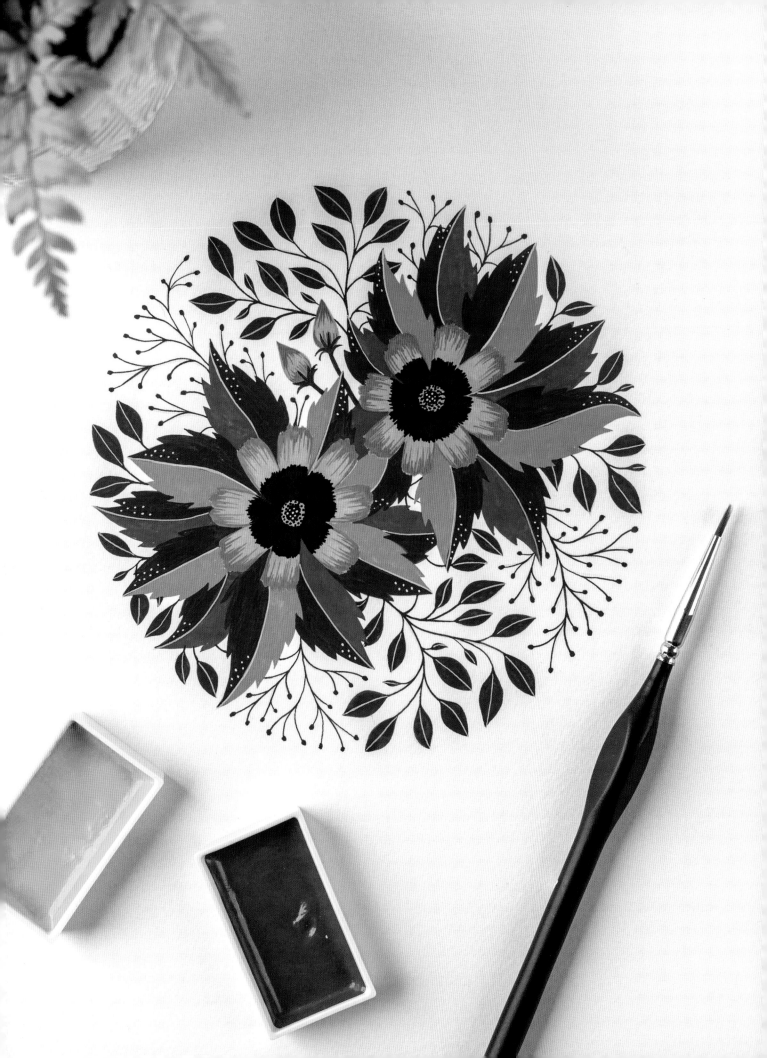

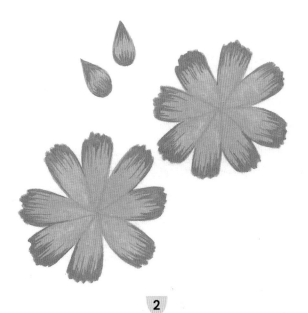

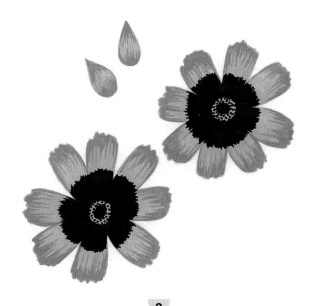

2

Using the dark mustard yellow, paint shading lines on the outer edges of the flower petals, directed inwards towards the centre. Also paint a few shading lines on the buds, from the top extending downwards and from the bottom extending upwards.

3

Add details to the yellow flowers using the deep burgundy. Start with a solid circle at the centre of each flower. Leave a small gap, and then paint a ring of burgundy, with jagged edges, on top of the yellow flowers. In the yellow gap, paint some tiny burgundy dots.

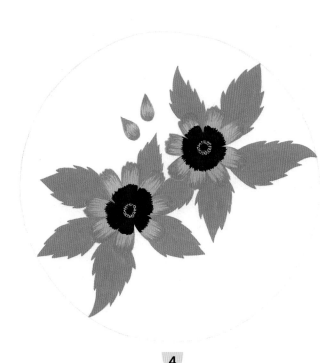

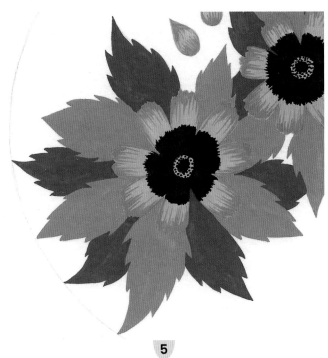

4

Using the lightest green, paint several large, notched leaves behind the yellow flowers. The largest of these leaves should be touching the outer edge of the circle.

5

Behind the light green leaves, use the medium green to paint some more large, notched leaves. Again, the largest of these should touch the edge of the circle.

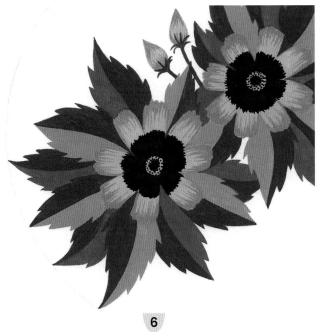

6

Paint half of each leaf using the dark green. Also with the dark green, paint two stems appearing from behind the leaves and joining up to the buds with a little spiky shape.

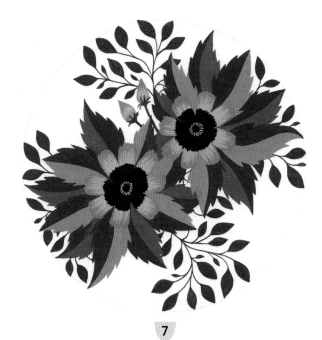

7

With the dark green, paint four sprigs of smaller leaves growing from behind the centrepiece of flowers and leaves. These should be branching off each other, growing in different directions and varying in size. Paint them right up to the edge of the circle.

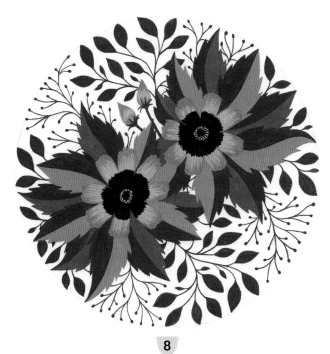

8

In the gaps between the sprigs of leaves painted in step 7, use the dark green to paint some delicate branching stems, each one ending with a tiny dot, and again paint them right up to the edge of the circle. Once you have painted these, the entire circle should be filled in with foliage.

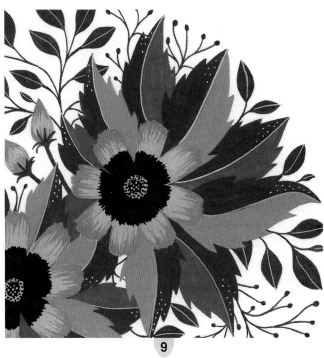

9

Use the white paint to add some final details – I have painted a line down the centre of each leaf, some tiny white dots at the centre of the flowers, and some white dots on the ends of the larger leaves. When your painting is completely dry, use an eraser to rub out any visible lines from your pencil sketch.

STARGAZER LILIES

It took me a really long time to master lilies – they are one of my favourite flowers, but I could never really get the hang of painting them. Here, I'm going to show you how I like to paint them, using layers of pink to create the distinctive shades of their petals.

COLOURS

Very light pink, light pink, medium pink, dark pink, light green, medium green, dark green, white, dark brown.

1

Paint the flowers and buds using the very light pink.

Sketch

Draw two six-petalled lily flowers – they have long petals that finish in a point. Around the two lilies, draw several lily buds, which are oval-shaped with pointed ends.

2

Using the light pink, paint a line down the centre of each petal of the flowers. Then paint shading lines from the centre of the flower extending outwards, and from the tip of each petal extending inwards. Add a few extra shading lines around both ends of the central line on the petals. On the buds, paint vertical shading lines from the top and the bottom, with some of the lines extending along the whole length of the bud.

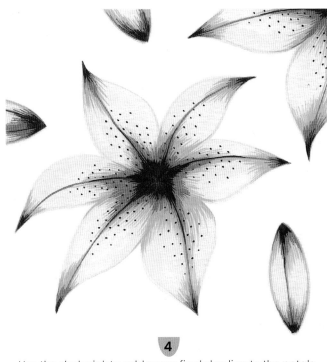

3

Repeat the previous step using the medium pink, going over the shading lines but not extending them quite so far along the petals this time.

4

Use the dark pink to add some final shading to the petals, just at the centre and at the very tips of the petals. Use the dark pink to add some tiny dots around the central line on the petals.

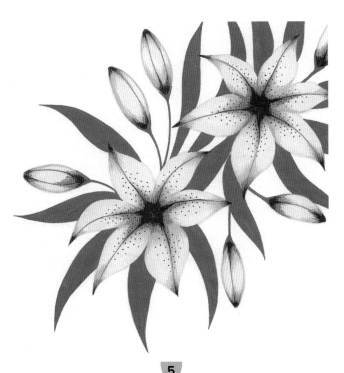

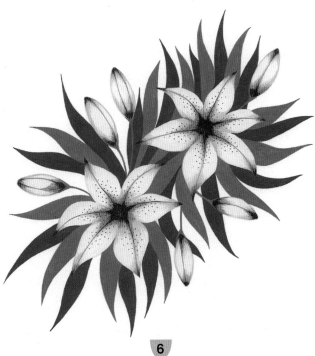

5

With the lightest green, paint long slender lily leaves growing from behind the main lilies, along with stems joining up the lily buds.

6

Between the light green leaves, paint more of the same type of leaves using the medium green. These should be overlapping and growing in different directions, for an organic look.

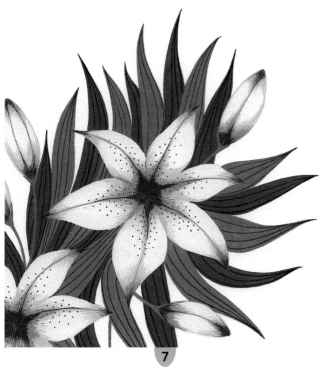

7

Along all the lily leaves, paint very thin lines using the dark green paint, following the natural curve of the leaves.

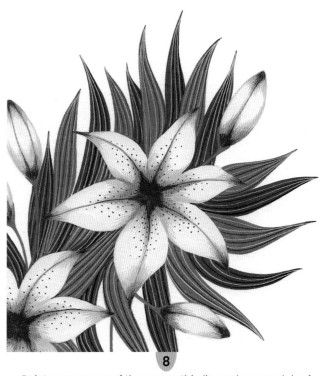

8

Paint some more of these very thin lines along each leaf using the white paint.

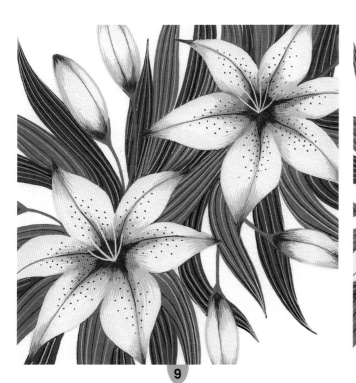

9

Starting at the centre of each lily, paint five or six thin white lines arching outwards and upwards.

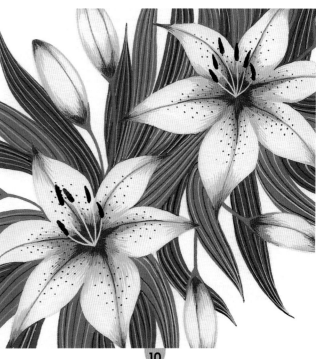

10

Using the dark brown, paint a small stamen in the shape of a grain of rice at the tip of each of these thin lines.

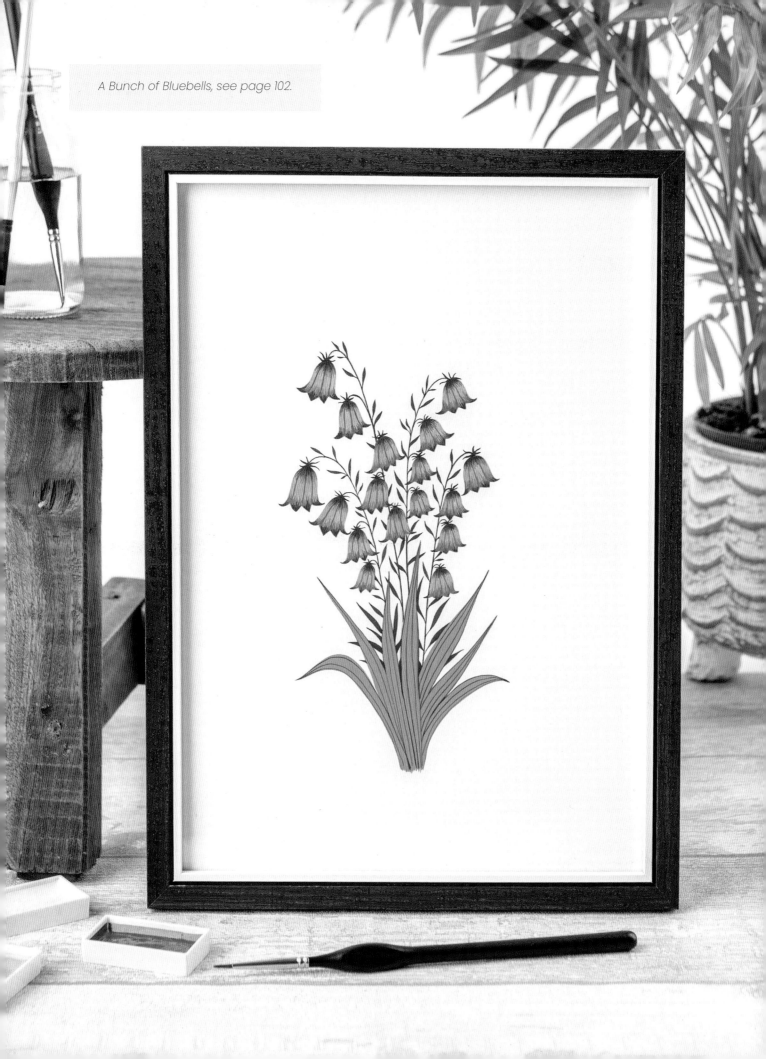

A Bunch of Bluebells, see page 102.